Anatomy &
Figure Drawin
Handbook

Anatomy & Figure Drawing Handbook

Viv Foster

Grange
BOOKS

AN OCEANA BOOK

Published by Grange Books
an imprint of Grange Books Ltd
35, Riverside
Sir Thomas Longley Road
Medway City Estate, Rochester
Kent ME2 4DP
www.grangebooks.co.uk

Copyright © 2004 Quantum Publishing Ltd

This edition printed 2008

ISBN: 978-1-84013-708-8

This book was produced by
Oceana Books
6 Blundell Street
London N7 9BH

QUMAFD2

Manufactured in Singapore by
Pica Digital Pte Ltd
Printed in China by
CT Printing Ltd

CONTENTS

ANATOMY

FIGURE DRAWING

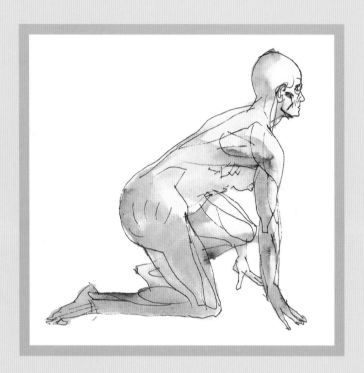

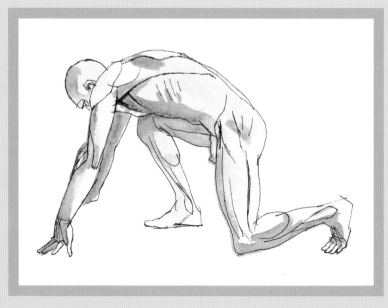

Anatomy

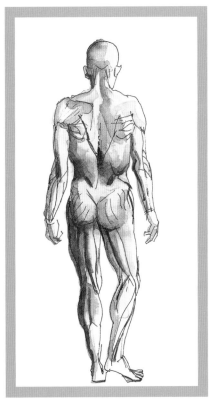

ANATOMY

Knowledge of anatomy will help the artist to look at a seated figure and sum up the basic tensions and emphasis within that figure. It is common to be versed only in the map of the human figure but this tends towards a two-dimensional interpretation. In the section on anatomy, an attempt has been made to create a three-dimensional view of the bones of the skeleton and the musculature of the human form. The full richness of the complex human machine is demonstrated in action.

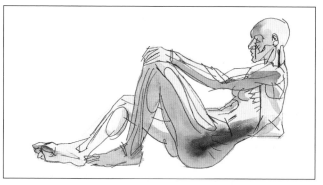

A study of perspective will show the artist how to create an illusion of space beyond the picture surface. Theories concerning the relationship of objects and figures within a three-dimensional space and how these can be represented on a two-dimensional surface will be explained. Much successful representative art is achieved through the discovery of the difference between what we know and what we see – it reveals the discrepancy between the appearance of an object and our preconceived ideas of what it looks like.

History

Until the introduction of the camera in 1839, any study or analysis of the human body and its complex machinery relied upon the drawings and annotations of artists and men of medical science.

Indeed, early medical books were illustrated with anatomical drawings researched by artists, and although artists concentrated on the external manifestation of the workings of skeleton, muscles and fat, rather than the specific functioning of the body's parts, there has always been a close link between artists and the medical profession in their search for knowledge and understanding of the records of early dissections are rare. The first accounts of any authority describe dissections performed by Erasistratus and Herophilus of the Ptolemaic medical school of Alexandria in the second century B.C. Evidence of study after this is thin; the religious association between body and soul fuelled early fears and superstitions and made it difficult for the examination of corpses to be carried out. Those who did so were threatened with excommunication, hell and damnation. In the thirteenth century, however, records of postmortems and autopsies were made for the University of Bologna, where for the most part the hapless cadavers were those of condemned criminals and vagrants. In addition, there are accounts of grave-robbing, not for gold but for bodies to dissect to quench the thirst for anatomical knowledge.

It was during the Renaissance, however, that the greatest achievements were made. This was the dawn of experimental science and research, when there was a new consciousness of man's dignity and of his powers to create a new environment for himself. No longer was the body of man regarded as an insignificant shell housing his immortal soul; it became the object of intense research and excitement. Artists and medical men now had the incentive to fight taboo and superstition.

Accounts of anatomical study by Renaissance artists exist and the most illuminating of these have come down to us in the secret notebooks of Leonardo da Vinci (1452–1519). In them he describes, in his cramped mirror-writing and accompanied by breathtaking illustrations, how on one occasion he examined more than ten human bodies and that 'as one single body did not suffice for so long a time, it was necessary to proceed by stages with so many bodies as would

• ANATOMY •

render my knowledge complete.' The revival of the classical link between art and mathematics led to the assertion that man, with his arms and legs extended, could be contained within both a circle and a square – the symbols of perfection and aesthetic beauty. This was the basis for the analysis of the human figure by Leonardo: 'The span of a man's outstretched arms is equal to his height. If a circle (with navel as centre) be described of a man lying with his face upwards and his hands and feet extended, it will touch his fingers and toes.' The German artist Albrecht Dürer (1471–1528) worked along the same lines trying to evolve canons of proportion. His two volumes on human proportion, originally conceived as a treatise of four volumes, contain carefully described formulas for the depiction of man.

Artists pursued a double purpose in attempting to determine these rules of proportion. First, they tried to define the symmetry of the body, in the Greek sense of balancing diverse parts within the whole, in the search for perfect beauty, and second, they tried to evolve rules to make their art simpler. In neither objective were they successful.

Notwithstanding the magnitude of these works, man's attitude to himself and his idea of beauty has changed greatly. Although we may presume the human body to have changed little over the centuries, artists have sought to portray it in various guises, emphasizing and seeking out the characteristics that they thought most appealing to their audience. Regardless of the manner in which the figure is portrayed, however, certain proportions remain constant. The centre of the body falls just above the crotch, at a point called the pubis. In general the human figure is usually from six and a half to seven head-lengths tall. This may vary from four to twelve head-lengths, according to fashion.

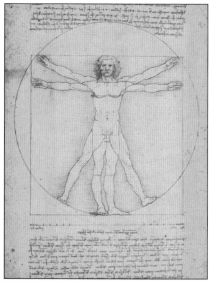

SKETCH OF THE PROPORTIONS OF THE HUMAN BODY FROM DE ARCHITECTURA BY VITUVIUS, Leonardo da Vinci

The Skeleton

Knowledge of the skeleton is fundamental to the study of anatomy. Without it, there can be no understanding of the body's balance, movement, twists or turns.

It can be well defined as the structure underlying the upholstery. A common mistake made by artists is to bypass an appreciation of the skeleton in favour of a superficial knowledge of muscles and fat; the one without the other makes little sense, just as foam cushions and fine covers without their underlying structure would collapse as soon as someone sits on them. By taking the trouble to learn this basic structure, any figure drawing will be more authoritative.

At the same time as researching the shape and position of the bones, it is necessary to understand how one affects another and why any movement of the body involves so many adjustments of the skeleton. When a figure is balanced on both feet, it appears very different from when the total body weight is shifted onto one leg. If the figure is standing on a level surface and takes the body weight on the left leg, then the pelvis will dip to the right so that the centre of gravity passes through the relevant points in the body to achieve stable balance. To compensate for this imbalance in the lower part of the body, the upper part of the body or thorax, tips in the opposite

direction; thus, the left shoulder dips and a beautiful snake of consummate balance emerges. This balancing of parts of the body is evidenced in all standing poses when there is no additional support, so that when a model lifts a leg, raises an arm or arches the back, there will be a compensating angle. Knowledge of the skeleton enables the artist to establish a point at which to begin – an anchor from which to cast off into the poetry of the pose, no matter how complicated.

Let us examine the different characters of the various bones. The vertebral column, or backbone, has the same function as a column supporting a building; the pelvis is bucketlike to protect vital organs. The rib cage is a strong, yet delicate enclosure protecting the lungs, heart and liver; the skull is an enormously strong packaging for the brain. The bones of the arms and legs work on the same principles of leverage applied in engineering. Although we each have approximately the same number of bones, we can be born with extra or absent ones and a few fuse together with age. Bones, however, can vary greatly from person to person – a rib cage can be

long and narrow, short and wide, rounded or flattened. The skeleton contributes to the build of the person, regardless of fat and muscles. You have your own body to look at to examine closely and to move as an aid to teaching you alongside diagrams, books and models, so let us begin with a detailed look at the skeleton.

BONES OF THE UPPER LIMBS

Shoulder

The shoulder joint comprises surfaces of several bones in the region. The scapula, or shoulder blade, is a thin, platelike bone of triangular form. It is placed high in the back and is capable of a great range of movement as can easily be seen in any reasonably thin model. There is a shallow socket at the upper part of its outer edge – the external angle – that furnishes seating for the head of the humerus in the upper arm. Long bones in the body are described as having a shaft with extremities. Usually the top extremity, as in the case of the humerus, is called the head. Also part of the shoulder joint is the clavicle, or collarbone – a thin, curved bone running from the top of the sternum to the shoulder joint. The movement of the clavicle is very important in determining many of the poses adopted by the figure as its angle very often

counters that of the pelvis. Attached to the clavicle and the scapula are the major muscles that control the movement of the arms and torso. The shoulder joint, like the hip joint, is an example of a ball-and-socket joint that permits a very wide range of movement.

Arm

The bones of the arm comprise, in the upper arm, the humerus, which is the main bone of the arm, and the radius and the ulna, both of which are in the forearm. The bones of the arm do not have to perform the same function as the leg bones – they have no need to support the weight of the upper body, for instance. Consequently, they are smaller and less thick although they bear considerable likeness to the bones in the leg. The extremities of the humerus have articular surfaces while the shaft allows, through grooves and prominences, for the attachment of the various muscles of the arm, shoulder and back. At its lower extremity the humerus is complicated in form, designed to link with the bones of the forearm. Of the two forearm bones, the radius is the outer and the ulna the inner. In saying 'outer' and 'inner,' however, some confusion can arise because these two bones are not united and are free to move over one another in certain directions. We can examine them in

relation to each other in different positions of the forearm. If we hold the arm with the palm of the hand held upwards, the bones will be lying side by side – more or less parallel to each other. Now, by turning the hand so that the palm faces downwards, the outer bone, the radius, lies obliquely across the ulna. In the former position the arm is described as being supine, in the latter prone. The movement itself is called pronation and the reverse action – that which rotates the arm from prone to supine – is called supination. The long bones of the forearm interrelate in a unique way, for it can be seen that the upper extremity of the ulna is large but its lower end relatively small. The radius, on the other hand, has a large extremity at its lower end but a small one at the top. It is important to understand why such is the case and to associate function with form. The inner of the two bones, the ulna plays a large part in the formation of the joint at the elbow, whereas the radius (the outer bone) is an important part of the wrist joint.

Elbow

The junction of the bones of the upper arm and forearm, the elbow, is a typical hinge joint. The movements made possible by such a joint are called flexion and extension. In flexion, the forearm is bent forwards onto the upper arm; in extension it is straightened so as to be in line with the upper arm. The joint is formed by the ulna, which is more significant in the joint than the radius, and the humerus, whose lower extremity is round in form to receive the large process matching it in the ulna. The general downwards movement is slightly outwards, giving the appearance that the forearm is splayed out in relation to the upper arm.

Wrist

The wrist consists of eight bones called phalanges. They adjoin the lower extremities of the ulna and radius, and below, they meet the finger bones, called metacarpals. They are tightly related and form a mass of bony structure between the arm and the hand.

The eight bones comprising the joint are arranged as two sets of four – the anterior, or back ones, can be felt in the wrist where they are overlaid with the tendons of the muscles travelling down to the fingers. The movements of the wrist are limited. When it is bent forwards, it is said to be flexed; when bent back, it is called extended. There is greater flexibility in the flexing than in the extending movement. The wrist is also capable of movement from side to side. When turned to the inner side, it is called adduction; when turned to

the radial side, it is called abduction.

Hand

The skeleton of the hand, connected to the wrist, comprises the bones of the palm and fingers. The palm bones, the five metacarpals, are long bones that at their top extremities meet the wrist and, at the bottom, four of them meet the bones of the fingers (phalanges). The remaining one (the outermost one) meets the thumb. The phalanges total fourteen in all – three in each finger and two in the thumb. The bones of the first row are the longest and the length diminishes towards the tip of the digit. The bones at the end of the fingers have a surface that allows the nail to be attached. By forming a fist and examining the rows of knuckles, the junction of all these bones can be easily seen.

The range of movement rendered possible by these bones is wide: the fingers can be separated and closed again and they can be bent at each of the joints along their length. The thumb possesses a greater range of movement than the fingers – it can be brought into opposition to each of them. As a means of harnessing the skills needed to pick up objects, the thumb is a unique digit. It has a musculature that gives it both its range of movement and great strength and enables the hand to perform delicate tasks.

BONES OF THE TRUNK

The spine, or vertebral column, is the main support for the head and the rib cage; it also makes the chief anchorage for the legs and the arms. The length of the spine is, on average, shorter in the female than the male.

The spine is composed of a related series of bones, twenty-six in all – seven cervical, twelve thoracic, five lumbar and one each sacral and coccygeal. The sacrum and the coccyx are fixed to the pelvis and form a solid foundation only capable of movement in conjunction with the other parts of the pelvis. Each of the movable vertebrae has spines – strong bonal appendages that seat part of the muscular system supporting the thorax and allowing major movements of the upper body, the shoulders and arms. The spines of the vertebrae are subcutaneous and some affect the surface appearance more than others. When a person bends forwards, for instance, the thoracic vertebrae rise to the surface and resemble a string of pearls lying beneath the skin.

If we now move from the spinal column at the back of the figure form, to the front, the rib cage appears as the most significant feature of the upper part of the skeleton. We should first examine the central support system of the ribs, the sternum or breastbone.

This is a flat, swordlike bone situated centrally in the thorax, supplying the point of origin for the ribs and the collarbones. The sternum rises to the surface and therefore becomes subcutaneous in its middle region.

Pelvic Girdle

The pelvis is an association of several parts that fuse at the hip to form a stable and protective mass of bone. It forms the major difference between the male and female skeleton both externally and internally. The female pelvis is wider and not so high as the male pelvis. At the same time it is of greater volume due to the differing function it must perform – the pubic arch is wider to facilitate childbirth. The pelvis itself is formed by the sacrum, the hip bones, and the coccyx. The two halves of the pelvis are visually separated by a marked ridge, well visible on both the sacrum and the ilium. The sacrum is lodged between the two iliac bones, with the weight of the body resting on it. Under the weight of the pelvis it acts like a two-armed lever; it dampens the force of sudden jolts from above and below. The hip bones themselves are formed by deep excavations on the lateral surface of the iliac bone and the head of the femur of the thigh. Here, the lower limb can move rather freely depending on the

agility and fitness of the individual. Ballet dancers, for example, can perform wonderful feats envied by most of us. The movement of the femur is dictated by the depth of the articular fossa. The femur can also describe circular movements, like the humerus in the arm, because of the ball-and-socket joint at the hip.

The bucket of the pelvis has an important function protecting essential organs, but from the point of view of the artist, it also performs an important function in balancing the body as it forms the base from which the spine springs. When observing the figure, particularly the female form, it can be very difficult to locate – all but impossible from the back view. By finding the ilium (or top ridge of the major bone in the pelvis) at the front, the pelvis will be more easily traced. The significance then of the position and angle of the pelvis becomes apparent, and together with the direction taken by the shoulders and the position of the feet, an accurate reading of any pose becomes more feasible.

BONES OF THE LOWER LIMBS

The bones of the lower limbs have features in common with those of the arms but there are also major differences. The differences are the result of the functional dimensions

concerned with balance and movement. The thigh contains one large bone, a long one of great strength, which allows for the attachment of many important muscles along its length. It is called the femur and consists of, in descending order, a head, a neck, a shaft and the lower process, which forms a major part of the knee joint. Such a summary of its parts does less than justice to the extraordinary shapes and twists that constitute the overall rhythm of this major bone. There are two bones in the lower leg, the tibia and the fibula. The tibia, the shin bone, comes very close to the surface along the greater part of its length. It can be seen on the inside of the leg and travels from the knee joint to the ankle. At its upper end it has a wide process that makes up the knee joint with the lower end of the femur. The fibula, along with the tibia, forms part of the ankle joint. The fibula is long and slender and lies on the outer side of the leg and its main importance is in furnishing attachment for several muscles of the leg.

Ankle and Foot

The ankle joint is between the lower leg and the foot and is formed by a meeting of the lower ends of the tibia and fibula and the tarsals of the foot. The tarsals of the foot are in direct correspondence with the carpals of the wrist – the tarsals, however, number only seven as opposed to the eight carpals in the upper limb. They contrast in other ways too, being larger, broader, and occupying more of the foot than carpals occupy of the hand. At their lower ends they abut the long bones that constitute the remainder of the foot and the five toes. The bones of the toes, like those of the fingers, are called phalanges.

SKULL

The importance of the skull in underlying the forms of the face and in its relationship with the trunk cannot be overstated. The bones comprising this feature are divided into two groups, those that form the brain box and those that underlie the face. The bones forming the cavity that houses the brain are called calvaria and they comprise the following: the frontal bone, which has two frontal prominences and two eyebrow arches; the parietal bones, which are anotriangular bones that together form the upper and lateral part of the calvaria; the occipitus is a shell-shaped bone that lies to the base of the cranium; the temporal bone is complicated in form and is always significant in drawing and in painting portraits. It is a bone with many parts and processes into which muscles are attached to contribute to the expressions of the face.

Now, let us look at the bones constituting the skeleton of the face. The maxilla, or upper jaw, constitutes the lower part of the structure that also includes the nasal cavity and the orbit of the eye. It also furnishes sixteen cavities for the teeth. The cheekbones, the zygomatic arch, connects the frontal and temporal bones of the cranium and the maxilla. Strongly marked features of the side of the face are often attributable to this bone. The mandible, the bone of the lower jaw, is the only movable bone of the skull. Looked at from below, it is of horseshoe form and it has seating for sixteen teeth. The point at which it meets the upper skull is called the articular process.

THE SKELETON (see diagrams on pages 18–21)

1 Frontal bone, the dome of the forehead.
2 Globella, the ridge of the eyebrow.
3 Zygomatic arch, the cheekbone.
4 Maxilla, upper jaw.
5 Occipital bone.
6 Mandible, lower jaw.
7 Cervical vertebrae.
8 Clavicle, the collarbone.
9 Greater tubercle, a tiny projection on the humerus to which muscles attach.
10 Scapula, the shoulder blade.
11 Sternum, the breastbone.
12 Ribs.
13 Thoracic vertebrae.
14 Humerus, the upper arm bone.
15 Epicondyles, bony projections at the elbow to which muscles attach.
16 Lumbar vertebrae.
17 Ilium, the hip bone, one of three elements that fuse together at the age of about nineteen.
18 Radius, the lateral bone of the forearm.
19 Sacrum, bone of five fused vertebrae.
20 Ulna, gives power to the elbow.
21 Coccyx, 'tail' of four fused vertebrae.
22 Pubis, by age twenty fixed to the ilium.
23 Greater trochanter of the femur, a bony projection to which muscles attach.
24 Ischium, by age twenty fixed to the pubis.
25 Eight carpal bones of the wrist.
26 Metacarpals, separate bones of the hand that slide over one another.
27 Phalanges, the bones of the fingers.
28 Femur, longest bone in the body.
29 Condyles of the femur, bony projections at the knee to which muscles attach.
30 Patella, the kneecap.
31 Condyles of the tibia, bony projections to which muscles attach.
32 Head of the fibula.
33 Tibia, the shin bone.
34 Fibula, to which many muscles and ligaments attach.
35 Malleolus of the tibia, the inside ankle.
36 Malleolus of the fibula, the outside ankle.
37 Talus.
38 Seven tarsal bones that articulate the foot.
39 Calcaneus, the heel bone.
40 Metacarpals, separate bones lining the foot.
41 Phalanges, the toe bones.

• A N A T O M Y •

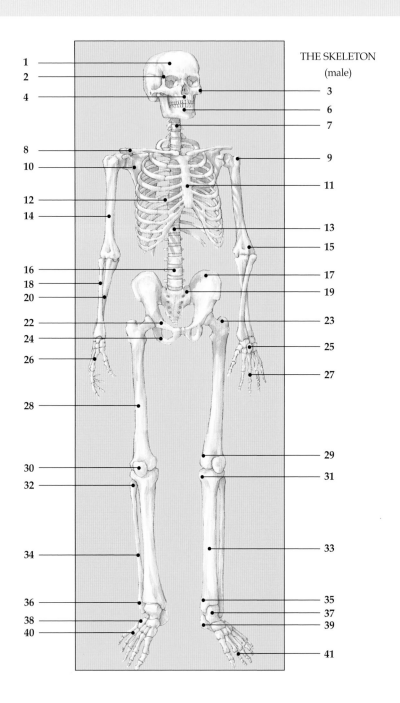

THE SKELETON
(male)

1
2
4
3
6
7
8
10
9
11
12
14
13
15
16
18
20
17
19
22
24
26
23
25
27
28
29
30
32
31
34
33
36
38
40
35
37
39
41

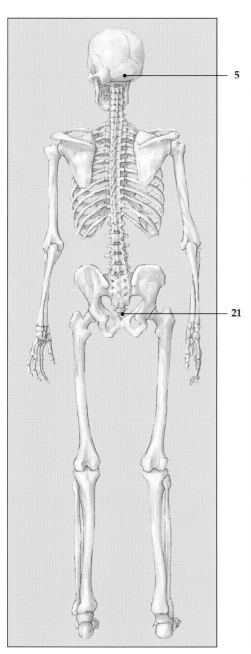

5

21

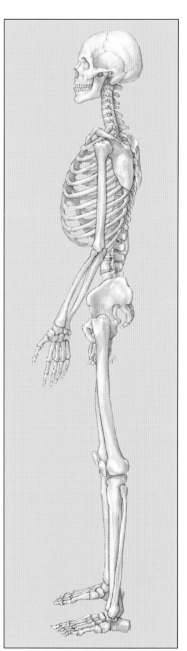

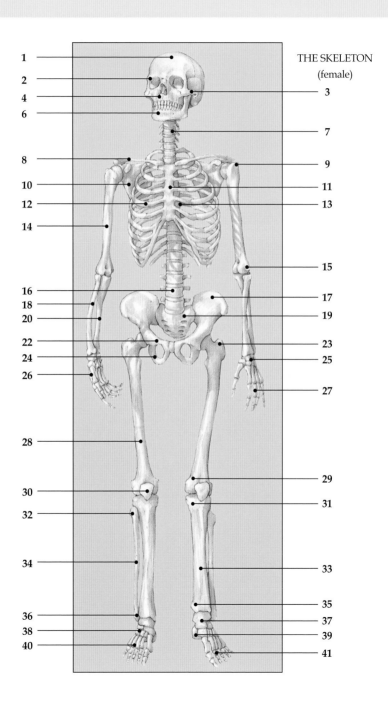

1
2
4
6

THE SKELETON
(female)

3

7

8
10
12
14

9
11
13

15

16
18
20

17
19

22
24
26

23
25

27

28

30
32

29
31

34

33

36
38
40

35
37
39
41

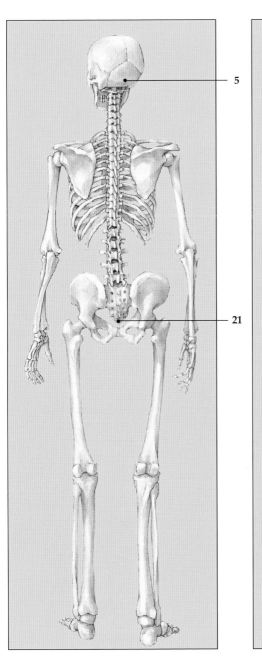

5

21

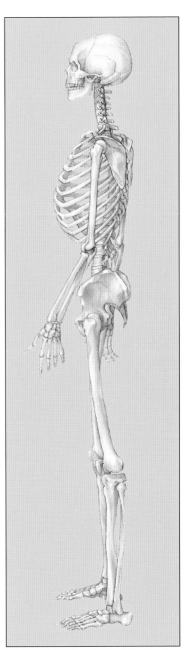

The Muscular System

It is the muscles that determine the appearance of the form of the body. Without muscles, the skeleton would be merely an inert mass of bones. They provide the power necessary for action.

Muscles of various kinds – differing in character and shape according to their intended functions – cover the whole of the superficial area of the body. Many muscular processes, however, lie beneath these superficial muscles and yet deeper ones below that.

The functions of the muscles vary. Some are there to hold a series of bones erect – as in the case of the vertebral muscles – others to activate two parts joined by a hinge – a good example is the arm. Some are massive, others small; there are muscles that carry great strength and power and muscles that control a range of fine movements. In spite of the differences, it is the characteristics they have in common that are of greatest interest to the artist learning anatomy and that will help him analyse the appearance of the life model.

NATURE OF MUSCLES

All muscles have an origin and an insertion – that is to say, they begin in one place and end at another. Sometimes this is on the same bone, but often muscles have their origin in one bone and insertion in

another. When a muscle contracts, it becomes shorter and harder, as can be felt by flexing the muscles of the upper arm until they bulge and stand out. A further illustration of the way in which muscles work can be made by examining how the upper arm and forearm, meeting at a hinge joint, are articulated by the relevant muscles. Here, the muscle travels from one bone across a hinge joint to be inserted into the other and when it is contracted it affects the movement of the arm. If the muscle passes over the joint, it will flex the limb; if it travels behind, it will extend it. It can go further and, from the upper bone, travel not only across the joint but beyond the lower bone to be inserted finally in another related bone below. In such a case, several articulations of bones will be affected, but if the muscle is deep-seated, it may not have a direct action – in such circumstances it is described as having indirect action.

Symmetry is an important aspect of the musculature of the human body; major muscles come in pairs on either side of the figure and smaller muscles, like those in the forearm or leg, are paired in the

opposite limb.

Let us examine those muscles that concern the artist – those that can be seen on the surface, giving the body its shape, and those that change in form through action. For ease of understanding, the muscles of the front of the body will be described first, followed by the back. Finally, the musculature of the head and neck will be dealt with. It is, of course, impossible to separate the muscles of the front, back and sides of the body, because so many muscles travel across and around, as well as up and down, the form; it is merely for the convenience of identification that we adopt the following method.

FRONT VIEW OF THE BODY'S MUSCULATURE

Thorax

The shape of the thorax, as we can see, is influenced by the rib cage, protecting major life-supporting organs. Of the muscles in the area, the deltoid muscle is shaped like the Greek letter delta, from which it takes its name. It has its origin in the front and back of the shoulder girdle and is inserted into the humerus. Its function is to raise the arm from the side and it is also active in pulling the arm backwards and forwards.

The pectoralis major, the chest muscle, is attached to the outer edge of the sternum, to the clavicle, and to the sixth and seventh ribs. Virtually all its mass is visible on the body's surface. Its action is to draw down the uplifted arm and it combines with other muscles to rotate the limb. In the fat that covers the pectoralis major the mammary gland is located, and in the female, this becomes the breast. Because the breasts lie on the individual muscles, they are placed well apart from each other. Both males and females have nipples, but in the male, these are the only indications of the breasts.

The external oblique is the muscle of the outer part of the abdominal wall. Its name describes it well – the fibres of the muscle lie in an oblique direction from its upper end, where it is attached to the eight lower ribs, down to its lower end, where it enters the pubis and inserts into the top of the pelvis. Its function is to pull the rib cage to its own side and it also works in pulling the pelvis upwards. The serratus magnus muscle is shaped like a fan and has extensive origins from the side of the rib cage. Not much of it is seen on the surface, but it affects the appearance of the trunk because it is familiar in poses in which the arm is raised. It has eight strips of fibre that spring from the eight upper ribs, and when seen in action, it appears as a row of radiating

ridges under the arm and down the wall of the trunk.

The next muscle, which has a significant effect on the appearance of the upper part of the body, is called the rectus abdominis. It is placed to the front of the trunk and covers the abdomen. It is attached above to the cartilages of the fifth, sixth and seventh ribs and to the sternum; at the lower end it inserts into the pubis. An interesting muscle virtually, it is divided by three transverse furrows, forming lines on the surface. The top two sections of the muscle are approximately equal in length and the lower section is the longest of the three. The furrows visible are the points at which the muscle most readily bends and its main function is to bend the trunk forwards.

The muscular structures of the front of the thorax do not, of course, work in isolation; they are interrelated with the back muscles and those of the thigh and, through those, the lower leg. Similarly, they have connections with, and interdependence upon, the muscles of the arm. It is well to remember the basic fact that all muscles are related, and that even the most subtle of movements will not only involve those muscles directly concerned with the action, but it will also activate other apparently unconnected muscles.

Leg Muscles

The muscles of the thigh, as seen from the front, comprise the exteriors that are four in number – rectus femoris, vastus medialis and lateralis and the crurens. The latter is deep seated and is therefore not seen in the superficial forms of the thigh. All of them are inserted into the patella – or kneecap – and together they form a fleshy mass. The outer muscles of the front of the thigh are the sartorius, tensor fasciae femoris and the iliotibial band. In addition, there are four that form the inner part – from top to bottom, the psoas and iliacus, pectineus, adductor longus and gracilis. The sartorius is a straplike muscle that travels obliquely from the anterior superior iliac spine of the pelvis at the outer front of the top of the thigh, to the lower inner thigh, and then behind the knee joint. It is the longest muscle in the body and links the thigh with the lower leg. Its function is to flex both the knee and the hip joint – it plays a part in everting the whole leg.

Before examining the muscles of the lower leg, look closely at the structure of the knee joint and its musculature. The surface forms of the knee are difficult to describe; indeed, it takes practise to read them in the model. But it is important to understand the various parts that come together to constitute the knee joint, and with

the benefit of a little experience it is easy to see what is going on. A problem encountered in figure drawing is found in the areas of soft fatty tissue that lie over most of the knee. The flowing line between the thigh, with its angle inwards from the hip to the knee, must continue to the lower leg via the knee without that feature being seen as a weakness – a point of potential breakage. The angles across the bony joints at the top of the knee, the bottom of the knee and the ankle joint complement each other. They all have rhythmic structures evolved to support the body weight and a determined range of movements. (The leg, like the thigh, is covered with a sheath of fascia that fits like a stocking.)

The knee has a bony cap – the patella – covering the front of the joint made by the femur in the thigh and the tibia and fibula in the lower leg. It is connected above with the muscles of the front of the thigh, and below it is linked by a ligament to the top of the tibia. On the lower part of the patella are two pads of fatty tissue, seen better when the knee joint is in repose rather than action, when the bony structure can be more clearly distinguished. It is easier to see in the average male model because, in the female, there is more subcutaneous fat in the region. At its outer side, the appearance of the knee joint is

affected by the iliotibial band that runs down from the thigh to insert in the outer panel of the head of the tibia. The sartorius continues downwards to below the knee on the inner side and inserts into the upper part of the shaft of the tibia. This muscle forms a curved prominence on the inward side of the knee.

The muscles of the front of the lower leg are divided into those that lie to the outer side of the tibia, which itself travels superficially down most of the surface, and those which lie to the inner side. Because there is a great mass of muscle at the back of the leg, some evidence of its presence is visible at the outer parts of the front. The tibialis anterior arises from the tibia and partly from the fibula and finds insertion in the metatarsal bone of the big toe. It lies on the outer side of the front of the leg and travels along the line of the tibia for most of its length. The extended tendon travels across the ankle bone and eventually is seen to be inserted into the base of the metatarsal bone. In its higher parts this muscle, being full and fleshy, conceals something of the harshness of the line of the tibia and gives a fullness of form to the outer part of the front of the lower leg. In action, this muscle is used to flex the ankle.

On the outer side of the tibialis anterior is the long extensor of the

toes, whose action is well described in the name. It arises from several points high on both the tibia and fibula and inserts, after separating into four ligaments, into the upper parts of the four outer toes. The tibialis anterior and the long extensor lie very close together at their origin, but when in the foot the tendons of each appear, and another muscle, the extensor of the big toe, can be seen between them. This has its origin in the middle part of the fibula and only becomes apparent on the surface at that point. As the name suggests, it is inserted into the big toe, having passed the ankle and travelled along the inner part of the instep.

MUSCULATURE OF THE BACK OF THE BODY

The muscles located in the back of the human body have, like all muscles, their own functions to perform.

Trunk Muscles

The trunk has important underlying muscles, some of which rise to the surface and affect superficial form. Other, deeper muscles do not, but their purpose is so central to the character of normal human form that they must be discussed in relation to the back as a whole. As we have seen, the spine comprises a series of related bones, structured to allow for a wide range of movement with maximum support in each position. Without major muscular processes, however, it would not be able to sustain the erect position, so one major function of muscles in the region is support. The erector spinae is the major muscle in this context. It runs down the side of the spine and, together with its twin, provides powerful support for the bones comprising the spine. It has its origin in the posterior and spines of the sacrum, in addition to the posterior superior iliac spinae and the upper part of that bone. Its fibres are complicated in arrangement, because the muscle separates and inserts into the ribs, but, viewed overall, it is a powerful column of muscle – and, with its partner, forms the ridges that straddle the spine. Because of the strength and depth of these muscles, the vertebrae run in a groove between the pair of them; overlaid onto the whole process are other very powerful and more obviously visible muscles.

The trapezius is so named because of the four-sided figure that is formed with the muscles of opposite sides. Its origin is in the middle of the back, rising above to the back of the skull and then finding its insertion down in the last thoracic vertebra. The fibres of the muscle reach into the outer part of the clavicle and are seen along the border of the acromion process of

the scapula. All this muscle is superficial and can easily be seen on the surface. Its action is needed in many movements of the arm and neck; when in contraction, it bunches to fully demonstrate its form. The latissimus dorsi is a great mass of muscle in the back. It arises from extensive origins on the spines of the lumbar and sacral vertebrae and travels up to attach its fibrous flesh in the fold of the armpit. It is visible over the lower half of the trunk, and in its upper regions it is overlaid by the trapezius, with the erector spinae below it. At its lower end the latissimus dorsi is attached to the iliac crest and higher up it passes over the lower part of the scapula. This muscle is employed when the arm is brought down from the raised position and in the rotation of the upper arm. It is also used when the body is raised through the power of the arms, for example, in push-ups or climbing.

The study of the superficial muscles in the back would be incomplete without the examination of a group that is only seen in part, but which, through their action, have influence on the body form. These are the muscles that control the movement of the scapula: the teres major, infraspinatus and rhomboid, which work together to pull the arm backwards. The teres major links the scapula to the upper shaft of the humerus.

The infraspinatus also has an attachment to the scapula but meets the humerus at its head. For most purposes, these two muscles are considered as one fleshy mass. Together with its deep-seated neighbour, the teres minor, the teres major acts to rotate the arm inwards and both the teres major and infraspinatus work together to pull the arm backwards.

The external oblique muscle has already been discussed in the description of the front view of the trunk but a significant portion of it is also visible on the back. As it comes down to make an attachment to the iliac crest of the pelvis, it wraps around to be partly overlaid by the latissimus dorsi.

Muscles of the Buttocks

One of the most significant visual characteristics, not only of the back, but also of the whole human form, is the buttocks. So much is dependent on development and individual shapes in this region – aspects of balance, of movement and of locomotion are all involved. As a mass, as part of the overall body system, what we normally see is, of course, the result of subcutaneous fat – especially in the female. But underlying this is a complex system of immensely powerful muscles – interrelated and interdependent – and both in form and function they are invariably of

significance to the artist. The forms, as they appear to the viewer, vary a great deal according to the position of the legs. It can be readily observed that movement of the lower leg, through lifting, flexing and extending, will take the superficial look of the buttocks from a sharp definition at the base – the junction of the buttocks and thigh – through to virtual obliteration of the change of angle.

The great flexing muscle of the buttocks is the gluteus maximus. It has extensive origin from the upper part of the pelvis, from the lower parts of the same bony process and from the coverings of the erector spinae muscle. Taken as a pair, the origins suggest that together they make a V-shaped form at the base of the back and this can be easily made out in the living model. The gluteus maximus muscle is superficial throughout and acts as a powerful extensor of the hip joint – straightening the thigh – and is employed in several other important movements, for example, when the trunk needs to be brought to the erect position from being bent forwards over the thighs. It is also a powerful factor in actions such as jumping, running up stairs and other movements and is used in abduction and adduction as well as the outwards rotation of the thigh. Man's erect stature is in no small part attributable to this great muscle

and as we look from its location at the meeting of back and upper thigh, then the manner in which the transition takes place into the thigh is very important.

Leg Muscles

In its lower insertion, the gluteus maximus runs into the outer fascia of the side of the thigh. This fascia is the strong fibrous substance that sheaths the thigh. From the centre of the back of the thighs, there runs a pair of muscles, the semi-tendinosus and biceps femoris. The origin of both is in the lower part of the pelvis, and after travelling side by side for the greater part of their length, they separate behind the knee – the semitendinosus inserts into the head of the tibia, the biceps femoris into the fibula. To the outer side of these two muscles is seen the vastus lateralis and the fascia covering the outer side of the thigh. On its inner side is the semi-membranosus, which underlies the semitendinosus and appears to either side of it. It is used in rotating the thigh. The adductor magnus, gracilis and sartorius are seen in part of the inner edge of the thigh.

Travelling down to the lower leg, the major muscular feature is the triceps – the gastrocnemius muscle. It has two heads that unite in the middle, and the third head of the complex – the lower head – called the soleus, is more deeply seated.

The triceps has its origin in the femur, whereas the soleus has its origin in the upper third of both bones of the lower leg. Further down, all three converge into the feature commonly known as the Achilles tendon, properly called the tendo calcaneus. Below and to the sides of these major muscles, it is possible to distinguish parts of muscles and tendons located in the front and side of the leg.

Muscles of the Arm

The overall form of the arm should be understood by the artist before he moves on to examine the muscles in detail. The arm hinges at the elbow and has a wide range of movements both in relation to the trunk and within itself. It can lift and support the weight of the entire body; it can be used to propel objects and control the movement of the fingers so finely that thread can be passed through the eye of a needle. The arm is thickest just below the elbow and it tapers down to the wrist. Above the elbow is a powerhouse of muscle – strong, versatile, fibrous muscles at the front, to the side and at the back of the upper arm. There are no isolated lower or upper arm forms – each curve interrelates with another and functions are, similarly, closely related.

We have looked at the deltoid from the point of view of its association to the muscles of the front. But, as has been said, it is a muscle that appears not only on the front, but to the side and on the back of the body, too. It forms a link between the chest, the back, and the arm and plays an important part in the form of the arm.

The muscle that carries the responsibility for bending the arm is the biceps. Its origin is in the shoulder joint and its insertion in the radius and ulna. To straighten the arm, the muscle brought into use is the triceps, which runs down the back of the upper arm. Both these muscles affect the appearance of the arm and are therefore important to the artist. In addition, the upper arm has on its surface the following muscles: the brachialis, which is covered by the biceps for much of its length, and the biceps brachi, which lies on the humerus and is used in the action of pronation. The brachialis itself flexes the forearm.

Travelling from the upper arm into the forearm is a pair of muscles that looks like one, the superinator longus and the extensor carpi radialis longus. The contour of the side and front of the elbow region is greatly affected by them and they are of use in rotating the radius and in moving the hand. Other visible superficial muscles of the lower arm are the extensor carpi radialis brevis, extensor digitorum and

extensor digiti minimi. Between them, these muscles exercise control over the movements of the fingers; the extensor digitorum divides into four flat tendons that travel across the wrist and down to be inserted into the base of each phalanx. The extensor carpi ulnaris controls the movement of the hand.

There are a great many deep-seated muscles running all the way down the arm, the forearm and the fingers but, although they are interesting to the artist, it is far more important to acquire an overall appreciation of form, function and character. To study the way muscles arise and insert is rewarding.

The main range of movements of the hand is contained in the thumb. It receives the attention of many muscles such as the opponeus pollicis, which is involved in the action of moving the thumb in opposition. This is the term used to describe the position when the thumb is opposite the other fingers and is a major reason for the development of human dexterity and manipulative skills. Each of the fingers is served by muscles that travel down across the wrist, which itself can be described as the connection between the forearm and hand. On the back of the hand are the flexor tendons and, on the front, the muscles of the palm. These muscles are divided into three groups: the thenar eminence –

the thick and prominent ones of the thumb – the hypothenar eminence and the palmar excavation – the muscles of the palm.

FRONT VIEW OF THE MUSCLES OF THE HEAD AND NECK

The head is obviously of great significance in the drawing of the figure and the set of the head on the neck is also very important. Within the total head form is contained the face, which varies in size according to several factors such as sex, age and individual characteristics. The way the neck sits on the thorax and grows from the trunk is to be considered first – so often the angle, the seating and the shape of the neck in relation to both head and body are misunderstood.

The neck can be rotated from its central position in either direction by about thirty degrees and the muscles that make this possible are mostly deep-seated and so have little immediate effect on the superficial form. There are many muscles needed to hold the neck vertebrae erect and, with the various tissues and tendons, they form a very strong column indeed. The front of the neck is not only affected by the muscles, but has an appearance greatly influenced by the alimentary canal and the respiratory system. But from the artist's point of view, it is the

superficial musculature and some aspects of these essential systems that affect the surface. The windpipe, the Adam's apple and the thyroid are features whose names are well known, and these do affect surface form, although the muscles and bones do not. The functions of such features are not especially important to the artist except when the neck is thrown back or depressed into the chest when they become evident.

The muscle that is most defined on the surface of the front of the neck is the sternocleidomastoid. It is attached to the clavicle and the sternum and runs upwards to be visible again in the area of the skull immediately behind the ear. The large protuberance felt behind the ear and into which the muscle is integrated is called the mastoid process. It is part of the temporal bone of the skull – and one significant way of showing differences between individuals in portraiture is by observing very closely the shape, form and variations of the direction and insertions of the sterno-cleidomastoid. The two sternocleidomastoid muscles converge in the neck and are inserted into the upper end of the sternum. The effect of both this point of insertion and the body of muscle itself has a profound influence on the look of the neck.

Between the pronounced V-shape of the sternocleidomastoid is the complicated form of the larynx and Adam's apple. But the importance of the contribution to surface forms made by these two muscles cannot be overstated – in almost all action and movement of the model, they are apparent and extremely significant. The deep trough between the points of insertion of these two is called the sterno-clavicular joint.

BACK VIEW OF THE MUSCLES OF THE HEAD AND NECK

Seen from behind, the head and neck are dominated superficially by the trapezius, sternocleidomastoid and smaller, deeper muscles. The strength of the trapezius has already been discussed, as has its participation in the movements of the head on the shoulders. The great strength and power contained in its mass contrasts well with the range of smaller facial and neck muscles nearby.

Muscles of the Face

The face is very mobile in character. It comprises large and small muscles capable together of a very wide span of activity. The cranium is seen from the front of the head at the topmost part and from it descends an important sheath of muscle called the frontalis. This

forehead muscle has its origin in the muscles above the eye and radiates out from the front of the skull. The orbicularis oculi is the muscle of the eye; it covers both eyelids and surrounds the orbit. Its action is to close the eyes by depressing the eyelids. The corrugator is involved in the actions of the eyebrow and brings the two eyebrows together.

Further down the face is the compressor nasi – a flat, triangular muscle that lies to the side of the nose. It can narrow and pull the nose down. The orbicularis oris encircles the mouth and takes responsibility for closing the mouth and pursing the lips. It originates in the maxilla and mandible, that is, in both the upper and lower jaws. The quadratus labii superioris is a three-headed muscle that associates with the side of the nose below the orbicularis oculi. Its function is to raise the upper lip. Deeper, but still significant in influencing surface form, is the levator anguri oris, which affects the angle of the mouth. An extremely important muscle that, in many cases, can be traced along its total length, is the zygomaticus major. It takes its origin in the outer surface of the zygomatic bone and is inserted into the angle of the mouth. It has significance in actions such as extreme openings and vigorous movements of the mouth, for example, when a person grimaces, yawns or screams.

The mentalis is a short muscle below the mouth form. It affects the movement of the skin on the chin. Small muscles such as the depressor anguli oris and the depressor labii inferioris are used in actions of the mouth, but the two major muscles that control the actions of mastication are seen to the sides of the face. These are the masseter and the temporalis. The masseter is a short, thick muscle that has its origin in the zygomatic arch and inserts into the mandible. In action, it pushes the jaw upwards and is involved with any energetic closing of the mouth. The temporalis is a large, fanlike muscle that has its origin in the temporal fossa of the side of the skull. It is inserted into a point below the zygomatic arch, by which time it has become a converging tendinous bunch. This muscle is also involved in traction of the lower jaw and extreme movements of the mouth.

The organ of sight is the eyeball. It has the cornea on its front surface; the iris contains the coloured part of the eye. The ball sits in its socket in the skull and is wholly or partly covered by the eyelid, which is a cartilaginous shell. Eyelashes and eyebrows must be carefully observed – the former being longer towards the centre than at their edges. The hairs of the eyebrow generally lie in a lateral direction. The form of the mouth is affected

by the shape of the lips and the teeth. The upper lip is longer than the lower and projects out further from the overall form of the face mask. The base of the nose is called the root and from this point the breadth increases and the sides of the nostrils are composed of cartilage. The ear is sited at the level of the zygomatic arch – roughly halfway between the top of the head and the chin.

MUSCULAR SYSTEM (see diagrams on pages 34–37)

42 Occipito frontalis, the muscle of the forehead.
43 Temporalis muscle.
44 Orbicularis oculi, the muscle around the eye.
45 External carotid artery.
46 Zygomaticus major, the upper cheek muscle.
47 Masseter, the main chewing muscle.
48 Orbicularis oris, controls the lips.
49 Buccinator, stretches the cheeks.
50 Sternocleidomastoid muscle, helps move the head on the neck.
51 Trapezius muscle, keeps the head upright.
52 Infrahyoid muscles, straplike muscles that protect the larynx and assist the lower jaw.
53 Deltoid muscle.
54 Subclavian artery, main blood vessel to the arm.
55 Pectoralis major, the big chest muscle.
56 Infraspinatus, a sheet of muscle supporting the shoulder.
57 Brachial artery.
58 Triceps, at the back of the humerus.
59 Biceps, generally larger in men than in women.
60 Latissimus dorsi, a large sheet of muscle that turns the trunk.
61 Flexor carpi radialis, rotates the wrist.

62 External oblique, the outside of the abdomen.
63 Ulnar artery.
64 Flexor carpi ulnaris, moves the wrist and outer hand.
65 Gluteus maximus, the buttocks.
66 Gluteus medius.
67 Extensor digitorum, straightens the fingers.
68 Flexor digitorum, bends the fingers.
69 Sartorius, moves the thigh.
70 Biceps femoris.
71 Semitendinosus.
72 Iliotibial tract, main power for the lower leg.
73 Rectus femoris, controls knee movement.
74 Vastus lateralis.
75 Femoral artery.
76 Vastus medialis.
77 Patellar ligament, over the kneecap.
78 Gastrocnemius, the strength of the leg.
79 Posterior tibial artery.
80 Tibialis anterior, helps to raise the front.
81 Peroneus longus.
82 Soleus.
83 Digitorum longus, moves the toes.
84 Tendo calcaneus, the Achilles tendon.
85 Arcuate, artery services the foot muscles.
86 Muscle masses of the sole.

• ANATOMY •

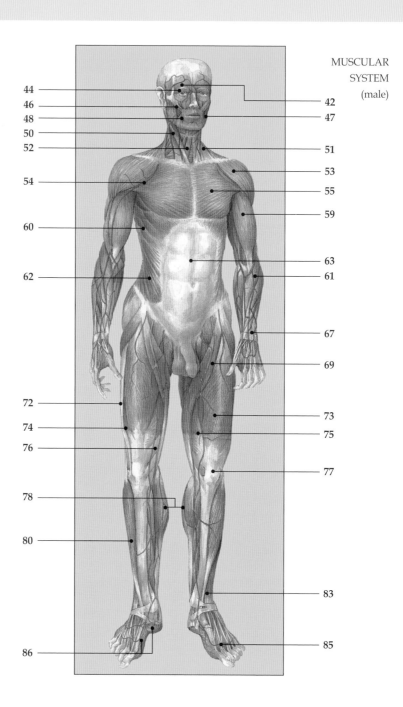

44
46
48
50
52

54

60

62

72
74
76

78

80

86

42
47

51

53
55

59

63
61

67

69

73
75

77

83

85

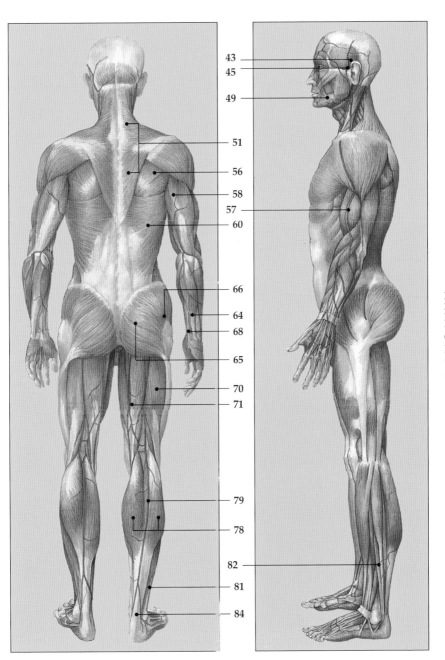

43
45
49
51
56
58
57
60
66
64
68
65
70
71
79
78
82
81
84

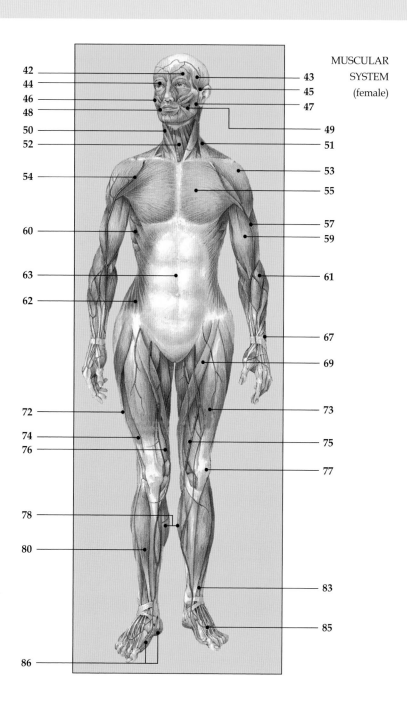

MUSCULAR
SYSTEM
(female)

42
44
46
48
50
52
54
60
63
62
72
74
76
78
80
86

43
45
47
49
51
53
55
57
59
61
67
69
73
75
77
83
85

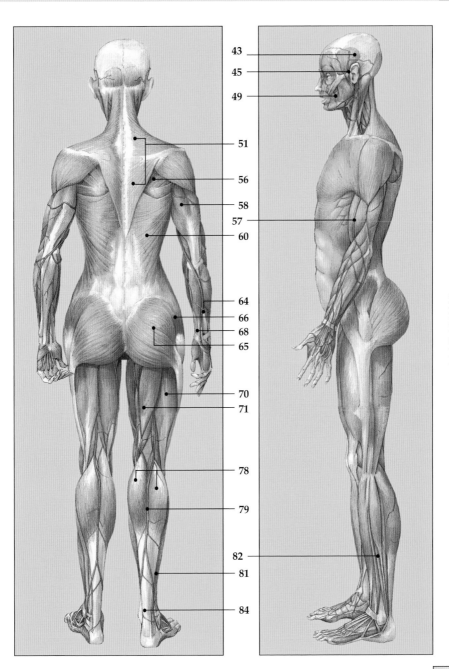

43
45
49

51

56

58
57
60

64
66
68
65

70
71

78

79

82
81

84

• ANATOMY •

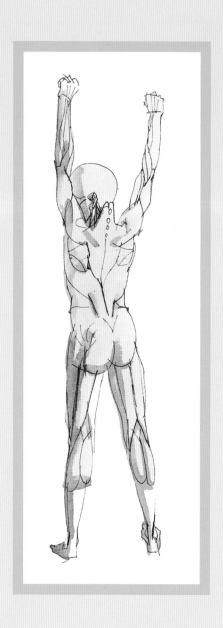

ANATOMICAL POSITIONS OF THE FIGURE

This section of the book illustrates the different poses of the body in both the male and female figures, showing the position of the muscles.

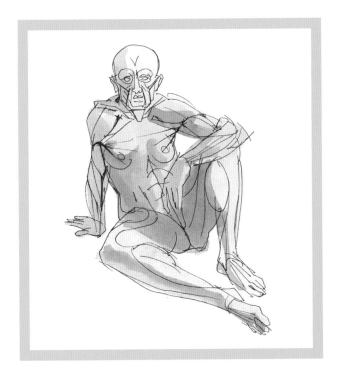

The Male Figure

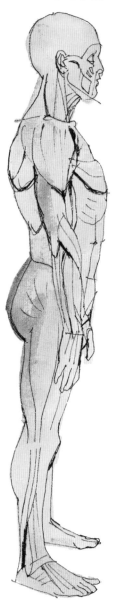

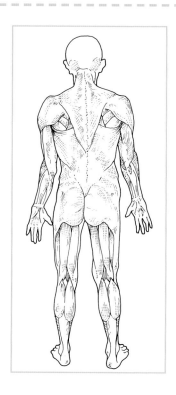

The feet are positioned in this relaxed, standing man to take an even distribution of body weight. Note, in the arms, the outward-splaying angle from elbow to wrist and the backward-facing palm (prone) of the relaxed hand.

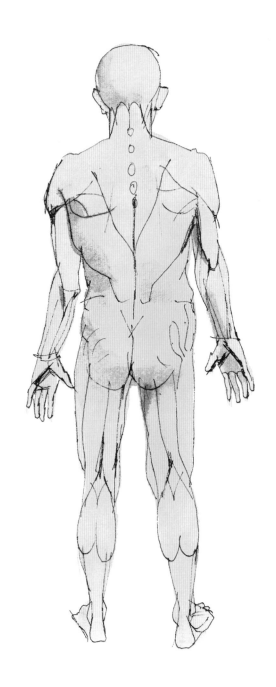

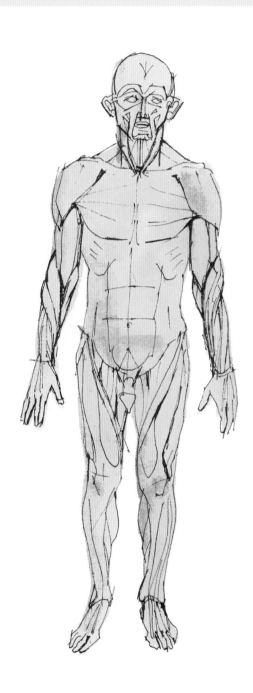

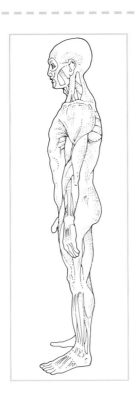

In all views, the slant of
the trapezius muscle,
between the neck and
collarbone (clavicle), can
be seen. The side view
demonstrates the curve of
the relaxed spine and the
angle at which the head
meets the neck.

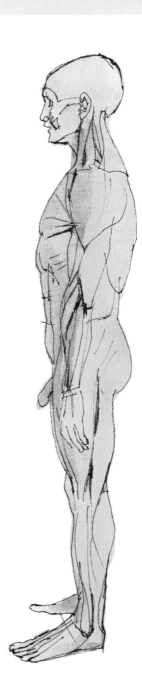

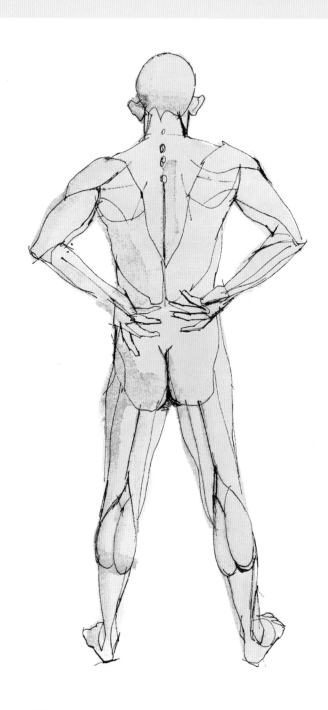

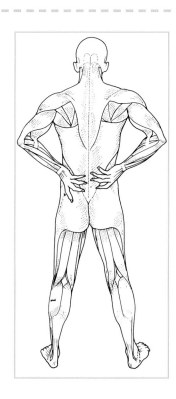

The model here has his hands on the back of his hips, resting on the upper buttocks (gluteus medius); in the back view, the trapezius muscle is flat, as the shoulder girdle is raised. The shoulder blades (scapulae), rotated on their axes outwards, can be seen affecting the surface form. As some action is involved, the feet are more widely set apart.

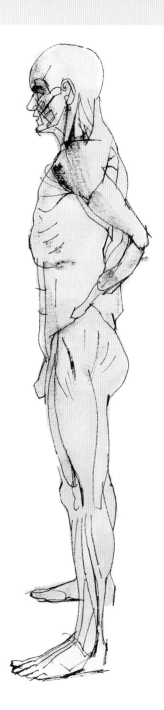

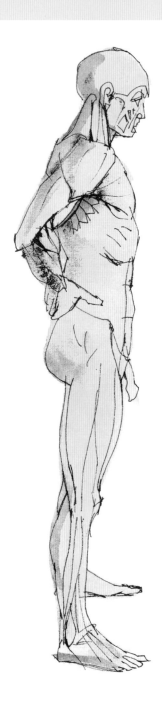

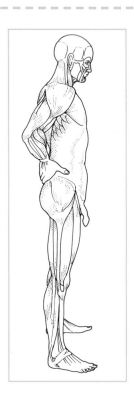

This position forces the shoulders and arms back, thereby clearly revealing the rib cage and the bunching of the upper arm muscles.

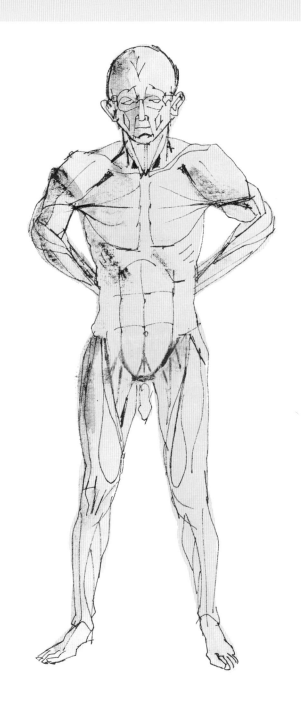

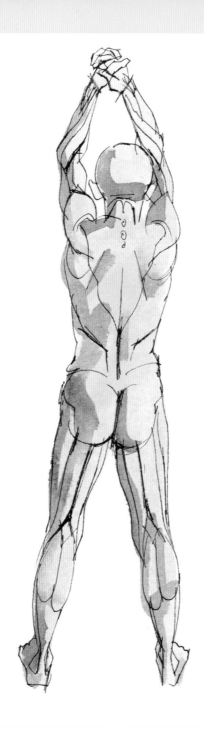

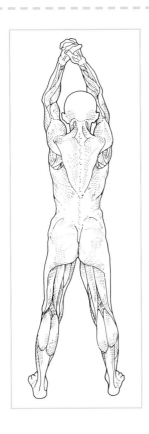

The action here, involving the raised arms and interlaced hands, affects the attendant muscular processes of the lower and upper arms and of the back (particularly the deltoid), capping the shoulder joint, and the latissimus dorsi, which can be seen originating under the arm and then running around to the back.

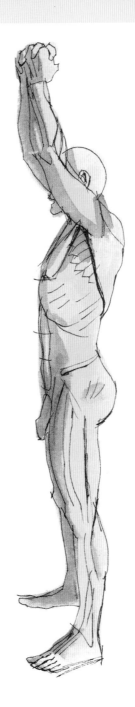

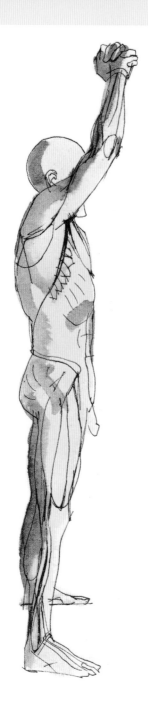

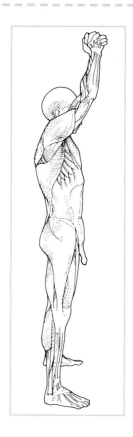

In the side view, the ridged serratus anterior is easily distinguished under the arm and, lower down on the hip, the ridge of the iliac crest. Although the major action is contained in the upper part of the body, we can see in the back view how the leg and buttock muscles are also involved.

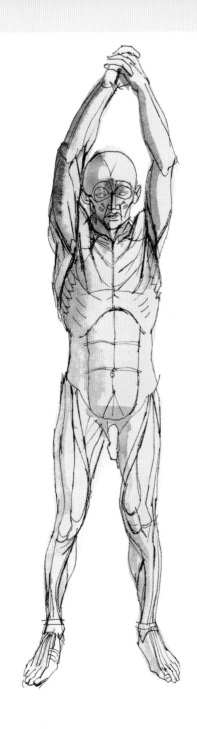

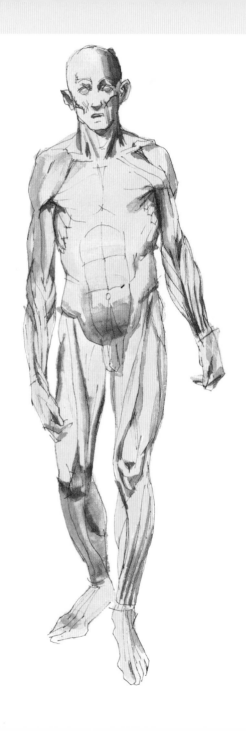

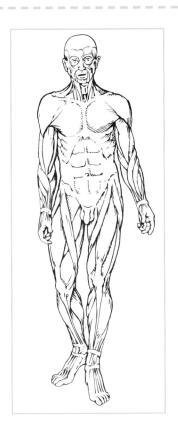

In this relaxed walking pose, the weight is in the process of being transferred from one leg to the other. Almost every muscle is involved in aiding actions or balance and compensation — where one part of the body mirrors the direction of action of another.

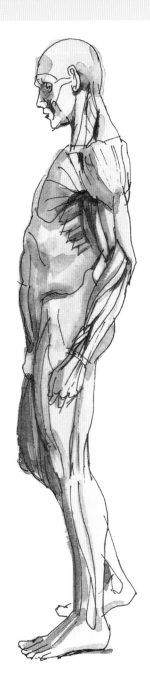

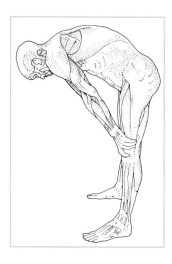

The legs are angled backwards to compensate for the forward weight of the body, which is solidly distributed on the platform of the feet. The skin of the back is pulled taut over the vertebrae, ribs and scapulae.

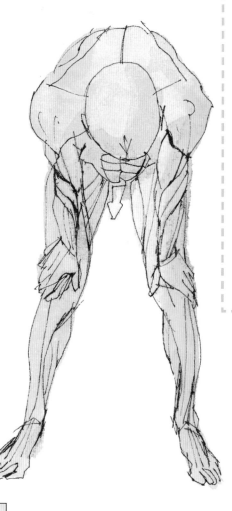

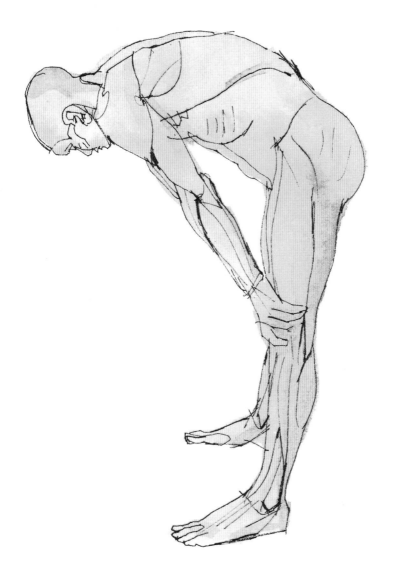

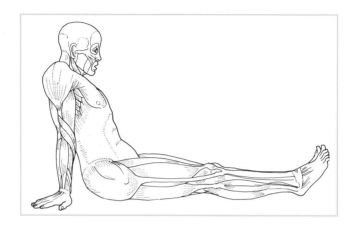

In an effort to aid the arms in keeping the thorax vertical, the stomach muscles (rectus abdominal) are rigid. Observe the inactive legs, where the flaccid muscles are pushed upwards by the floor, and the angle of the relaxed foot.

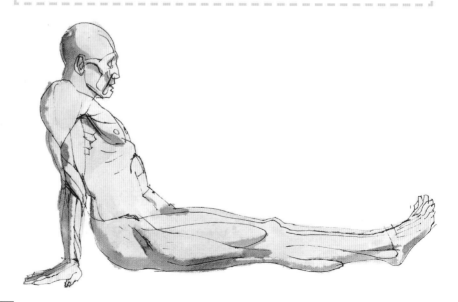

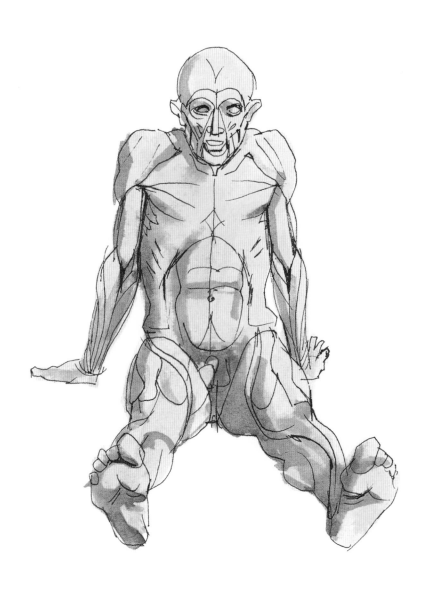

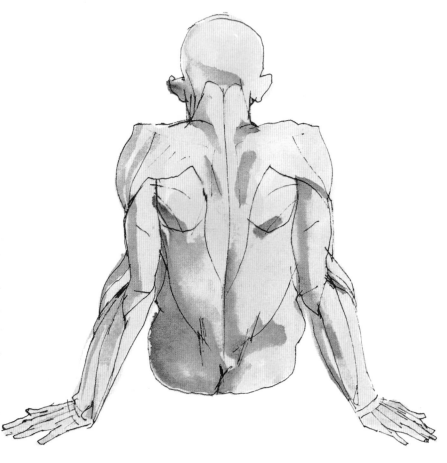

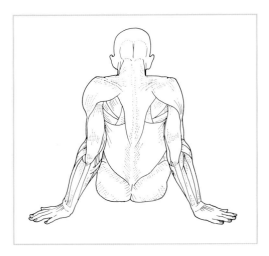

The buttocks and two hands in this pose form a weight-bearing tripod. The hands are platformlike, while the tensed muscles of the shoulders – particularly the deltoid – and arms are supporting the weight of the upper body in substitution for the vertebral muscles.

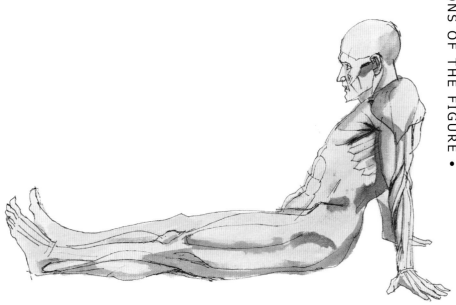

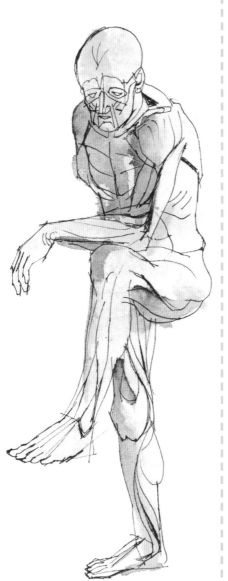

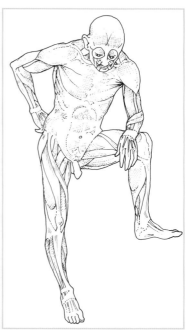

The forward position of the head makes it possible to observe the ridge of the collarbones across the front of the shoulders and the shoulder blades at the back. This pose causes a pronounced hollow to appear at the base of the neck, between the clavicle and trapezius.

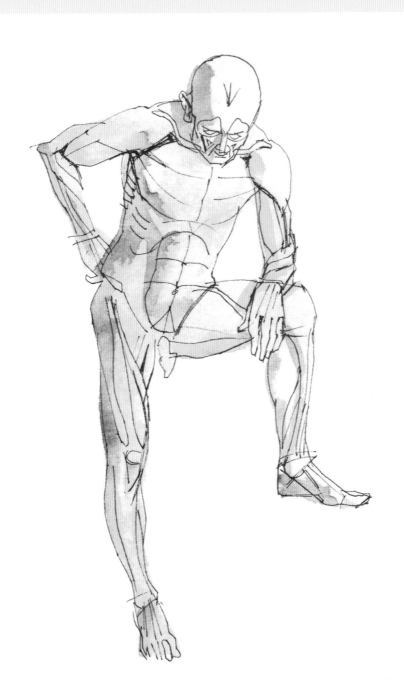

The Female Figure

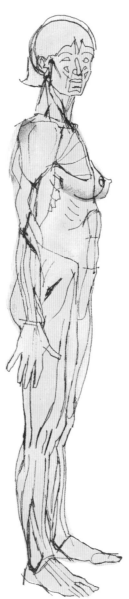

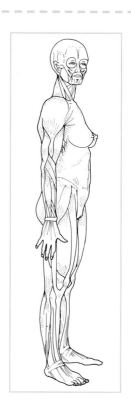

The female figure differs from that of the male in some obvious ways, such as the breasts and genitals, but there are also some less explicit characteristics that are important to the artist. In general, female hips are wider and the shoulders are narrower.

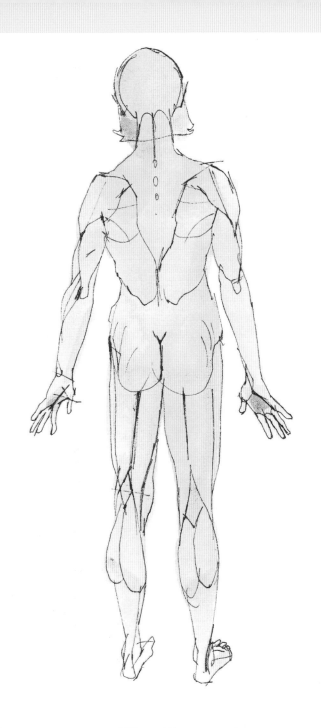

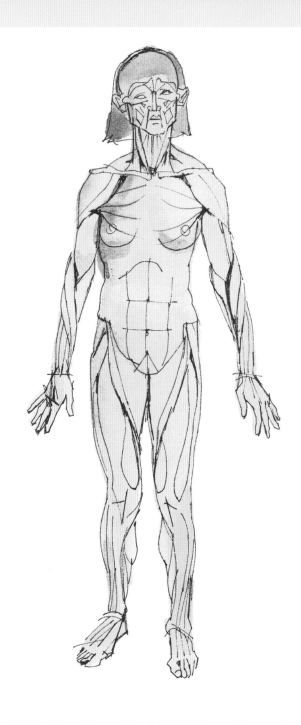

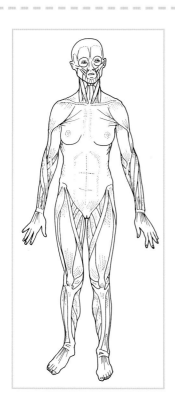

The surface form of a female body is usually less well defined because of subcutaneous fat that covers the muscles. Certain points of the female figure are often finer, for example, the neck, wrists, knees and ankles.

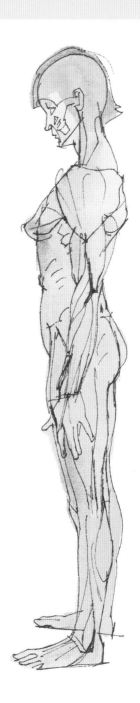

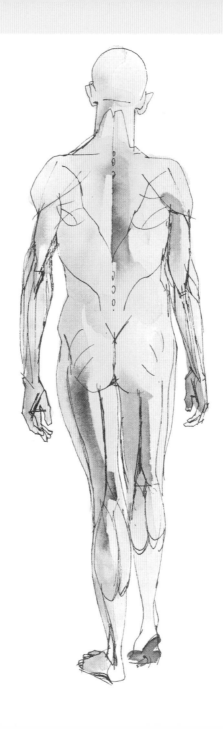

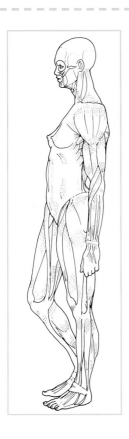

This relaxed walking pose demonstrates the counterrhythms of the body well. The head is slightly tilted to the right, causing the trapezius muscle at the base of the neck to tense on the left.

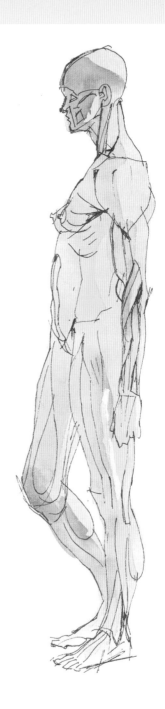

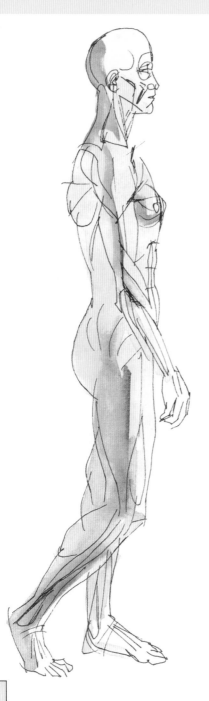

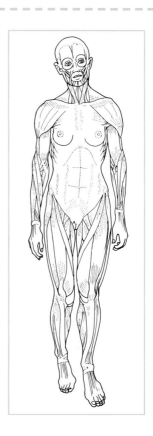

The shoulder girdle is sloping to the right in compensation for the pelvic girdle, which is angled the other way in raising the right leg. Laterally, the same counterrhythms are visible as the right shoulder and arm swing forwards, balancing the left pelvis and leg.

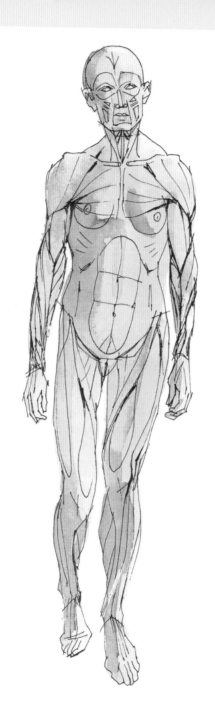

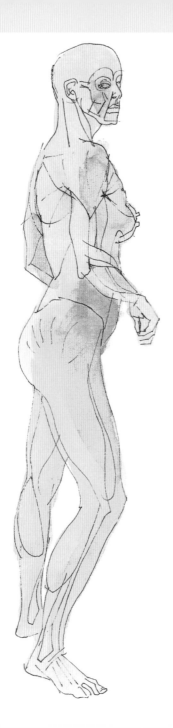

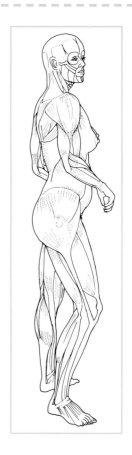

Dancing involves movement in most of the body. To allow for the upper contortions of the body, the legs are widely placed, one taking more weight than the other but by no means fully supporting.

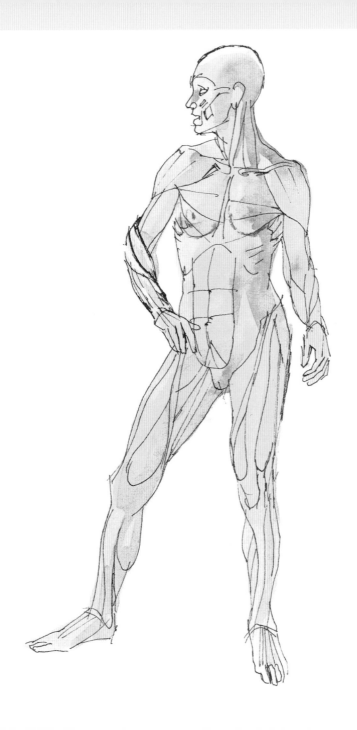

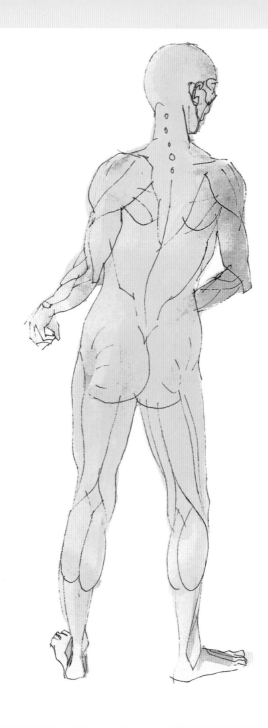

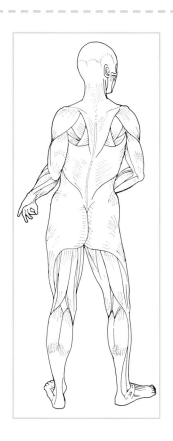

Again, the counterrhythms of the body are important, demonstrated by the back-view lateral flexion of the spine. The turn of the head allows us to see the well-defined muscles, implying the limit of the range of movement.

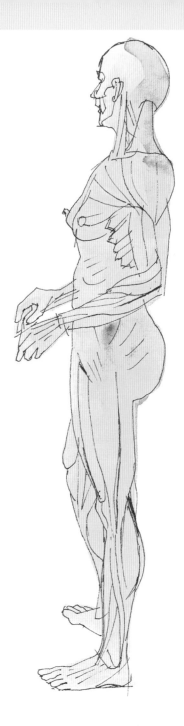

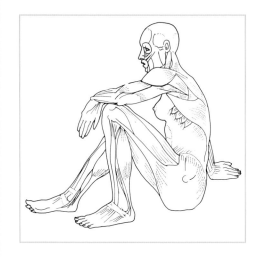

In such a pose, where it is difficult to retain all the angles of the various parts of the body in one's mind, the artist can be aided by an overhead view of the main points of balance and the positioning of the limbs.

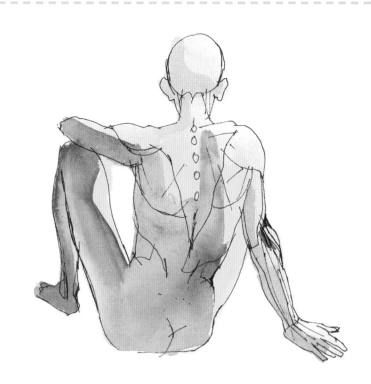

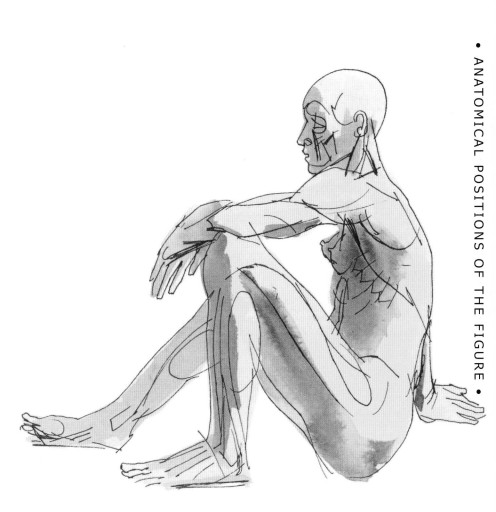

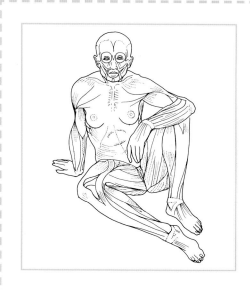

This pose is visually interesting from most angles due to the geometric shapes of the limbs and torso. The contrast between the tensed supporting right arm and relaxed left arm is noticeable.

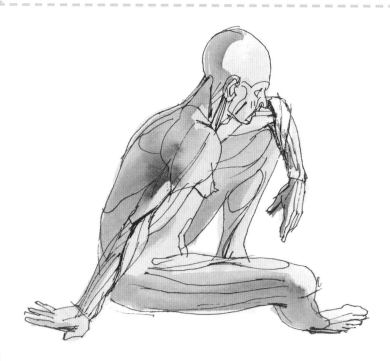

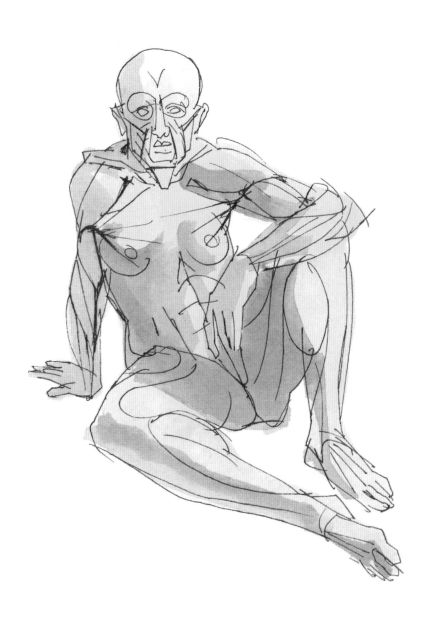

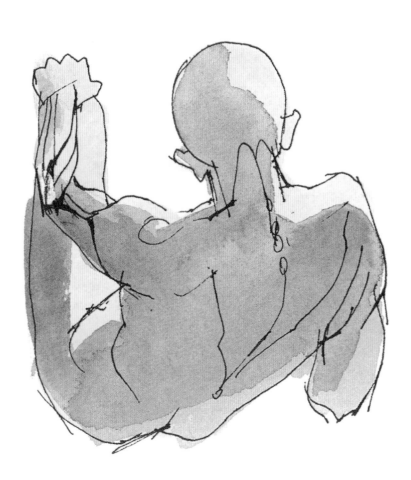

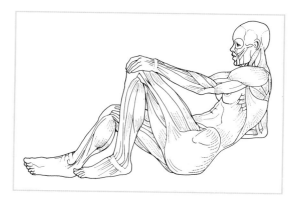

This classic pose of the prone figure propped on one arm is notable for the change of angles across the midline of the body, as seen in the front view.

The lower half of the body is relaxed but the shoulder and arm muscles are employed to support the upper part.

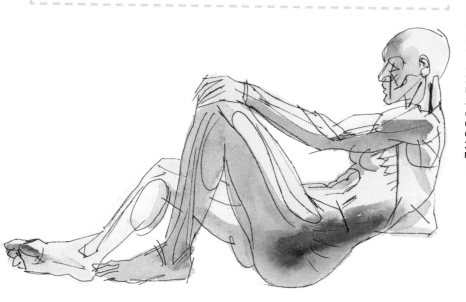

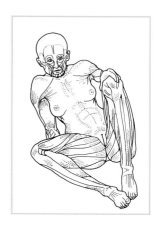

The symmetrical nature of the figure can be seen in the right-side view, where the head, torso and right leg form the diagonal of a rectangle formed by the arms and left leg.

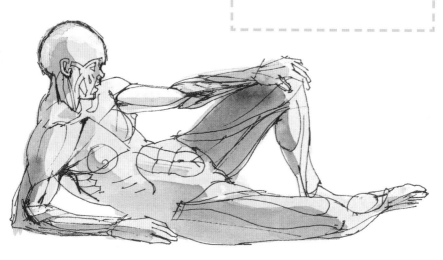

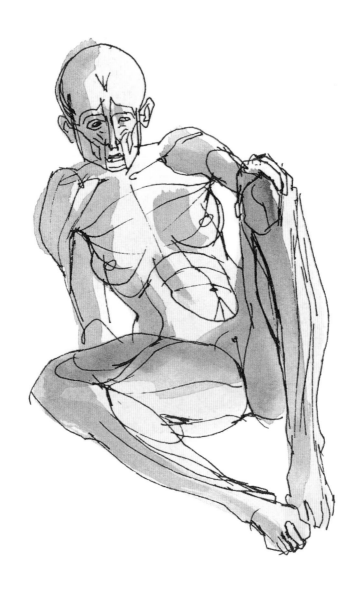

Adolescent Male Figure

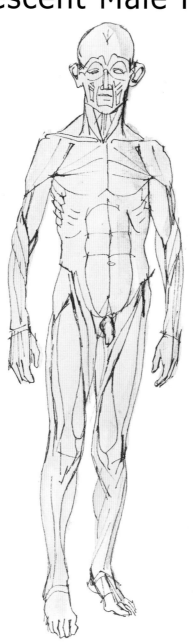

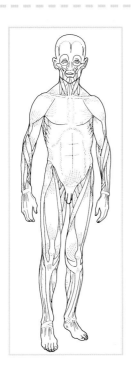

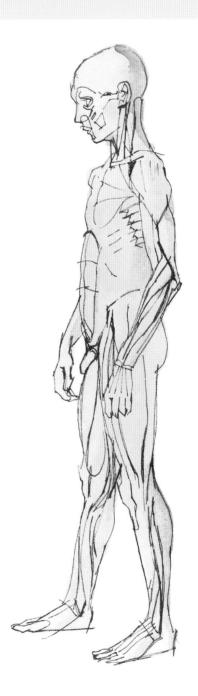

In this simple standing pose of an adolescent boy, the differences between young and adult bodies become apparent. Most important are the relative proportions between the length of the leg, length of torso and size of head to body. The front view demonstrates well the perspective of figure drawing. The line taken from heel to heel, from toe to toe, from hip to hip and from shoulder to shoulder all converge to a vanishing point on the right.

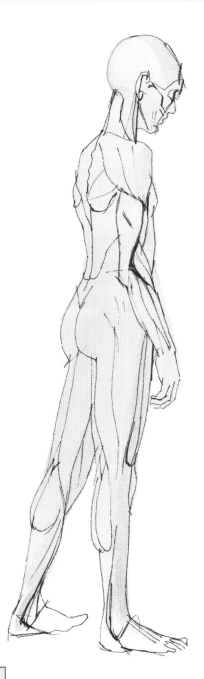

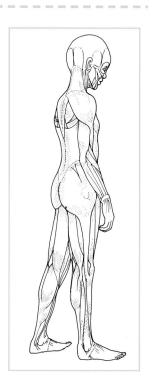

Muscular development in an adolescent boy is not so advanced as in an adult, so the shoulders and upper torso appear narrower and the general surface form is less modelled.

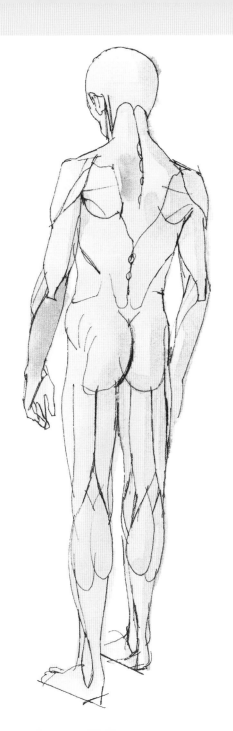

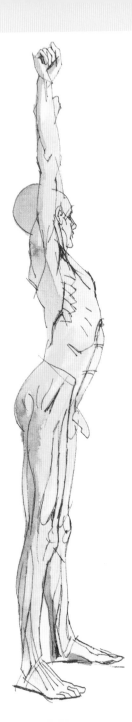

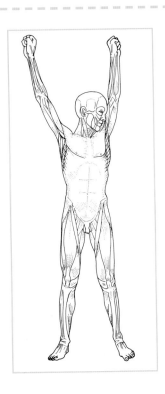

This stretching pose exposes the surface definition of the rib cage. The deltoid muscle is clearly visible, travelling from the scapula across the shoulder joint to the clavicle in front.

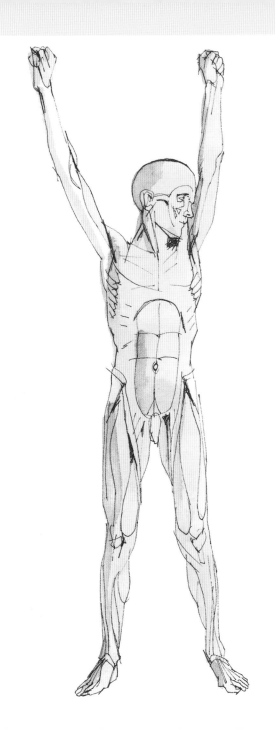

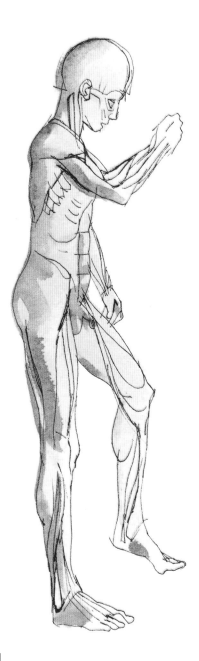

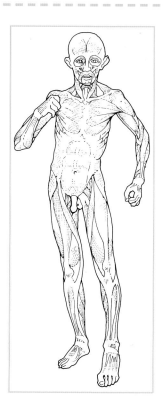

This marching boy is concentrating his body effort in the action of the shoulders and arms. The slightly uncoordinated action of a boy has been captured here and the slant of the head and clenched fists seem to portray concentration.

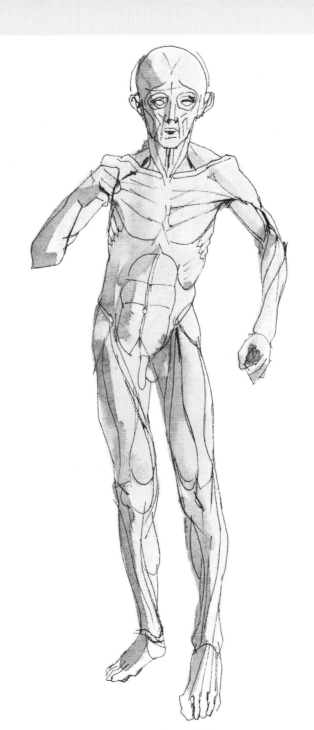

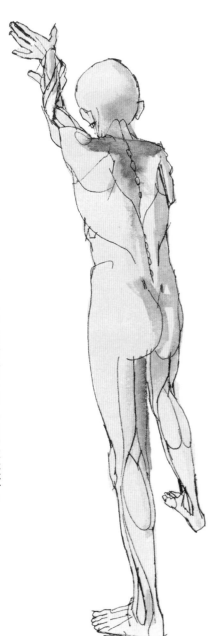

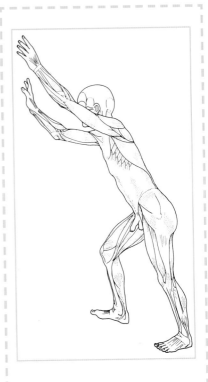

In stretching forwards and up, the boy's weight is mainly taken on the left supporting leg, which is duly tensed. Because of the stretch, the spine can be read well.

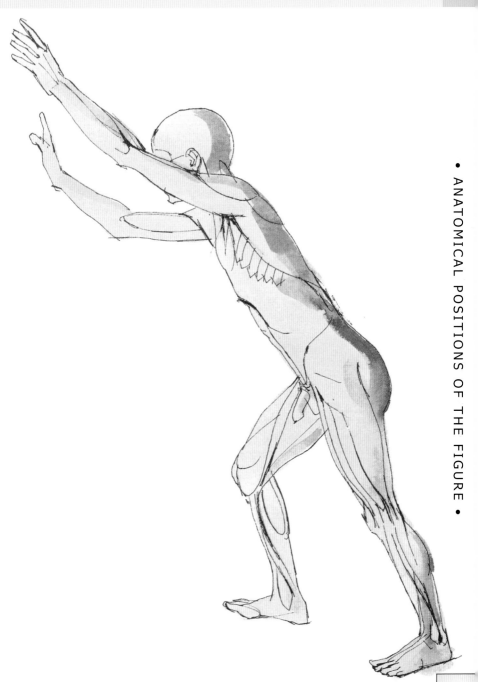

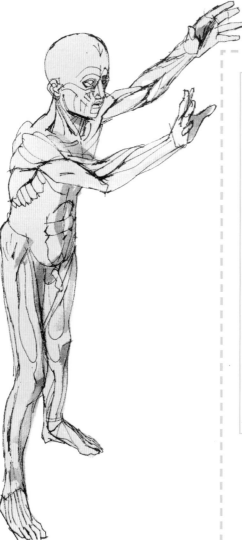

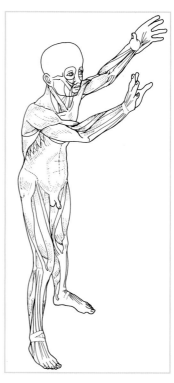

The upwards thrust of the arms causes the muscles of the upper torso at the front and back to come into action. The scapulae can be seen affecting the surface, pulling upwards as the arms move forwards.

Anatomy of the Face

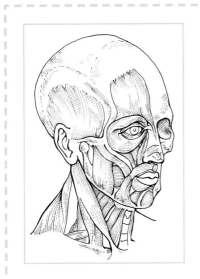

Here we see the muscles of the face and front of the neck that affect surface form. Particularly noticeable is the muscle around the eye (orbicularis oculi) and the zygomaticus major, which runs diagonally across the cheek. The quadratus labi superioris turns down the side of the nose and the orbicularis oris encircles the mouth, enabling it to perform delicate speech movements. In most people these muscles are covered by a layer of subcutaneous fatty tissue, except when the face is very thin or elderly.

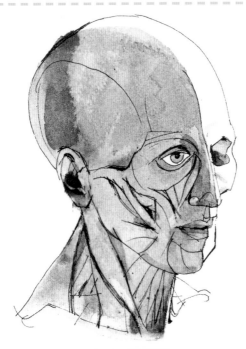

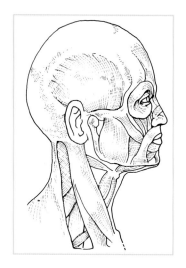

On the left, the junction of many of the face muscles can be seen at the corner of the mouth. The triangularis, passing under the chin, is very noticeable here. In most people, neck muscles are more obvious, as the subcutaneous fat is usually very thin. The sternocleidomastoid is the main muscle, running from behind the ear across to the breastbone, and is particularly prominent when the head is turned. There is muscle covering the cranium, too: the temporalis above the ear and the occipitalis behind it. The occipito frontalis, on the forehead, wrinkles the brow.

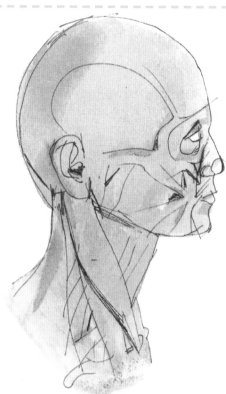

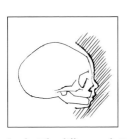
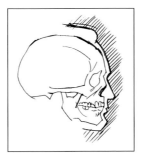
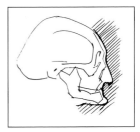

Look at the differences between the three skulls above.

At left is the skull of a baby; in the centre, a young adult; and at right, an old person. The profiles drawn show how different the facial proportions are between these ages. The teeth in the skull alter the face considerably, increasing the distance between nose and chin and making the lips more prominent.

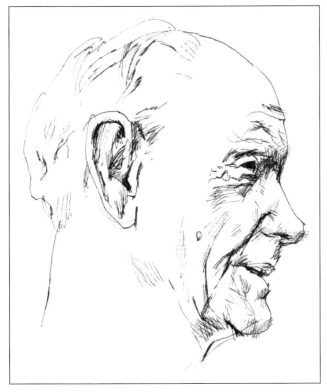

The octogenarian man, seen in profile here (left) and face on (next page), shows how the aged skin has set in furrows due to repetitive muscular activity. There is little fatty tissue, so the form of the cheek and brow muscles is easy to read.

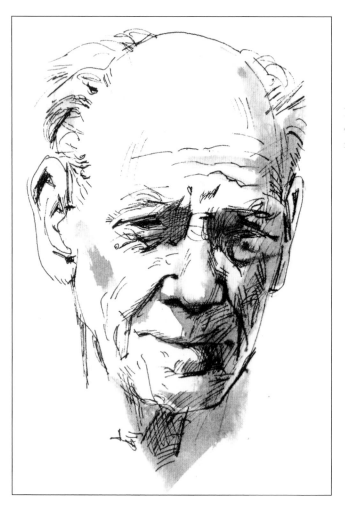

Left: The octogenarian man, face on.

A sample of the infinite range of expressions capable by the facial mask is illustrated on the opposite page. The smiling infant and yawning baby (top) have translucent, supple, unlined skin. Beneath, the fatty tissue conceals the muscular form. The angry, haughty, and scowling men (below) show how muscles can contort the face. The scowling man uses the forehead muscles to furrow his brow, his nose and cheek muscles to wrinkle his nose and mouth muscles to lower the outer angles.

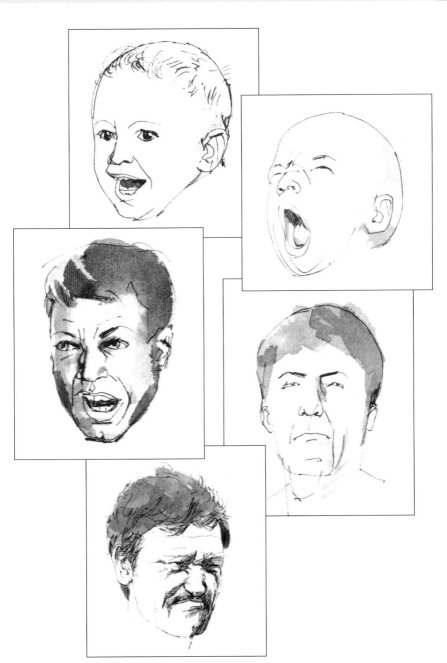

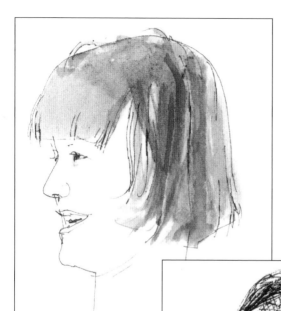

A smile affects not only the shape of the mouth but also the cheeks and, particularly, the eyes. This smiling girl (left) has few wrinkles to show for her age and enough subcutaneous fat to give a soft line to the face. The cheek muscles push up the covering fatty tissue, causing small pads to appear below the eyes.

The eyes of this older man (right) are almost closed in the act of mirth. The skin shows a tendency to wrinkle below the eyes, where the cheeks are pushed up against the delicate skin. A smile usually bares only the upper row of teeth.

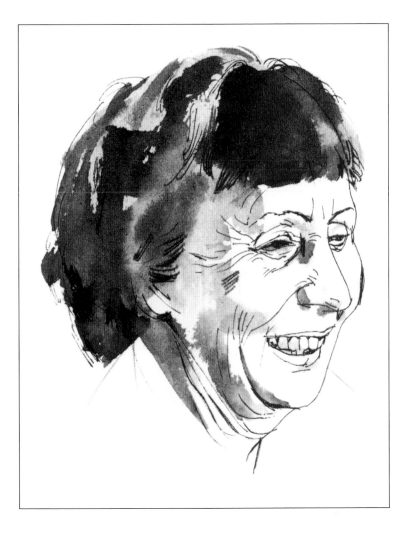

The face of this older woman bears witness to many years of smiling: the crow's feet running from the outer corners of the eyes and the parallel curved creases echoing the laughter lines at the side of the mouth. This sketch illustrates well the tiny folds of skin that form on the bridge of the nose when a person smiles.

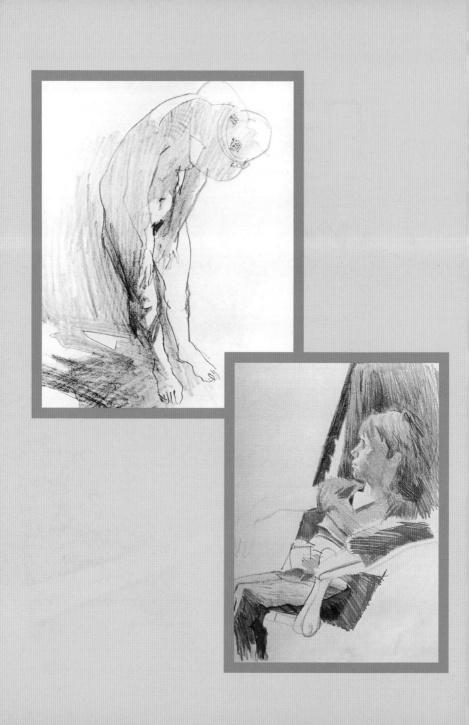

Figure
Drawing

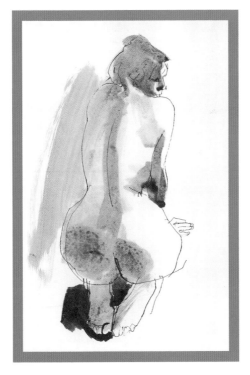

FIGURE DRAWING

To base figure drawing exclusively on a knowledge of human anatomy is both very difficult and inadvisable, so an alternative way of structuring the forms must be sought. Artists have usually acknowledged anatomical structure, but put it into simpler forms.

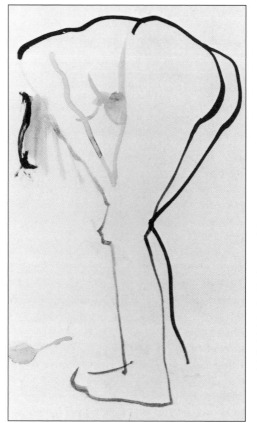

NUDE BENDING OVER
In rather simple terms, the brushed line here describes not only this moment of the pose, but the general feeling of movement in the body. This type of study provides essential practise in identifying this rhythm and putting it on the paper with a fluid and confident hand.

Figure Analysis

The human body is a figure in space, an object much like any other in that it has weight, mass and solidity. Unlike most others, however, it comprises four major parts: the head and neck, the torso, the arms and the legs. Of these the torso is the largest and has the greatest limitations in its range of movements.

THE GEOMETRIC APPROACH

A consensus of opinion among artists ancient and modern would suggest the torso in terms of an elongated cube connected at the lower part to the legs and attached at the upper to the cylinder of the neck. On top of the neck is the head form, basically suggested by a cube or another elongated cube with the spherical form of the cranium on top. The arms are suggested as cylinders, hinged at the elbows, as are the legs, similarly hinged at the knees. Feet are attached at right angles and are considered as platforms; hands flatten, spatula fashion, the narrowing tube of the lower arm. Toes and fingers are cylindrical, radiating out from a point set at the centre of, respectively, the front of the ankle joint and the wrist.

This is a useful, very basic guide to figure construction, but it must be made more refined and sophisticated. Putting these various forms together in a pile from the platforms of the feet up to the top of the head would be unlikely to

suggest a human body. This is because the interrelationship between parts is absolutely critical, the angles at which the separate bits join up being as important as the forms themselves. The neck is a good example, for it joins torso and head not as a cylinder placed in a vertical position, but as a cylinder tipped forwards from the one and inserted into the other.

AXES AND DIRECTIONAL LINES

Using simple geometric equivalents, the larger parts of the figure are basically cylindrical and each part has a central axis. Ease of feeling the axes is essential and they should be understood both in themselves and in relation to others. With practise, the limitations of movement and the pivot points become immediately apparent. Directional lines should also be established. Two such lines run across the shoulders and across the hips, lying horizontally and parallel to the ground plane. If the weight of the body is taken on one foot, the leg will be tense and firm

and the other leg used primarily to balance. Michelangelo's famous marble statue of David in Florence is in just such a pose and the angles of the shoulders' and hips' directional lines have altered accordingly. The hip is pushed upwards on the side of the supporting leg and the shoulder drops towards the hip to compensate. Michelangelo's drawing of Adam for a fresco on the Sistine Chapel ceiling also shows these same two directional lines used to convey the rhythmic bend in the torso. Axis lines and directional lines can be used to establish the position of volumes in space.

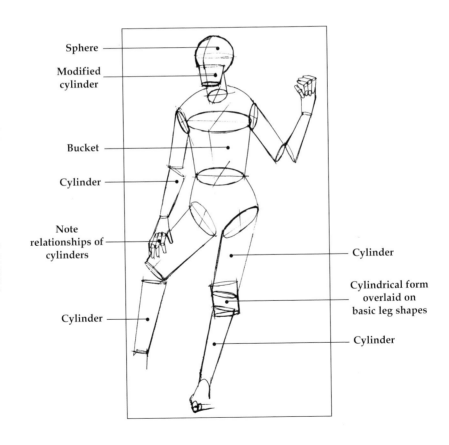

Sphere

Modified cylinder

Bucket

Cylinder

Note relationships of cylinders

Cylinder

Cylinder

Cylindrical form overlaid on basic leg shapes

Cylinder

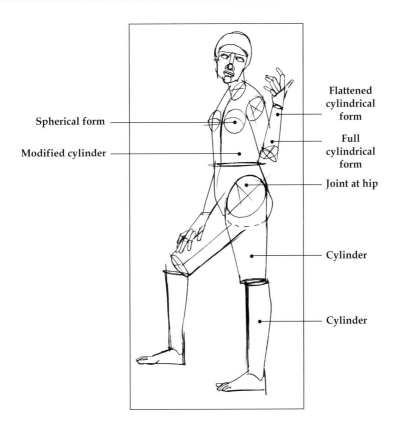

Spherical form

Modified cylinder

Flattened
cylindrical
form

Full
cylindrical
form

Joint at hip

Cylinder

Cylinder

These three diagrams (pages 104–106) show the basic geometric structure of the figure, using the cylinder and sphere, along with modifications of each. In the diagram above, a side view is shown and, in the diagram overleaf, an elaboration of that on the page opposite. Practise drawing the figure as a collection of these simplified volumes in order to help you acquire a firm understanding of this basic structure. You need not literally represent the figure in terms of cubes, spheres and cones, but bear them in mind constantly as you draw as a basis for interpreting the volumes of the figure. The figure will be subjected not only to gravity but also to other forces resulting from the various postures it adopts. This affects the shape of the basic forms – flattening, stretching or compressing – but does not in any way change their essential structure. It will take a great deal of practise to learn to depict accurately this multitude of possible shapes, but it is important to remember always that the most important aspect of figure drawing is the ability to sum up the pose as a whole, establishing its movement and position in space. Only on a basis such as this is it worth the effort of making a detailed investigation of the structure.

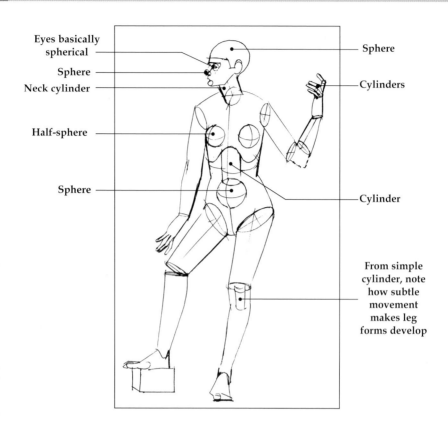

Eyes basically spherical

Sphere

Neck cylinder

Half-sphere

Sphere

Sphere

Cylinders

Cylinder

From simple cylinder, note how subtle movement makes leg forms develop

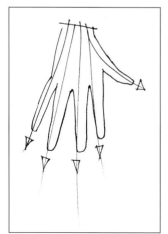

Left: The fingers radiate from the wrist with the thumb in opposition; it is essential to observe and understand the range of movement of the thumb.

Right: When making initial sketches, it is a good idea not to attempt to treat the fingers separately but rather to draw their overall shape.

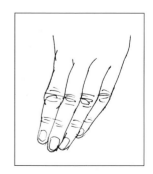

Characteristics of Drawing

The dictionary defines drawing as the art of making pictures with pencil or pen and ink. This is a perfectly adequate explanation, but drawing can be both much simpler and much more complicated than that. Any mark made deliberately onto a flat surface, even if it is only a line drawn into sand with the finger, can be described as drawing.

At the same time, the distinction between drawing and painting is not always clear. As a general guide, drawing can be distinguished from painting because the former is primarily concerned with line while the latter has more to do with tone and colour, even though many drawings contain elements of all three. A painting, however, often makes use of tone, colour and form to create a total illusion, to make the viewer believe, momentarily, that the frame of the painting is a window through which the painted scene can be observed as if it existed in reality. A drawing is much more a statement about reality than it is an attempt to copy it. Although an artist may represent three dimensions in a drawing by using solid modelling, many drawings are nothing more than a simple outline that separates one area of the paper from the next. The space defined and enclosed by line in some mysterious way takes on a dynamism of its own, existing in a self-imposed context.

While it is this linear quality that helps to distinguish drawing from painting, the line also distinguishes drawing from reality. In real life nothing has a line drawn around it. Things can be perceived because they are made up of solid, light-reflecting masses. Their apparent outlines change as either they or the viewer move from place to place. The drawn line is a visual symbol, standing for the difference between a solid shape and the space surrounding it. It is not the line that receives attention, but the shape of the space or mass that it implies. Even so, the line does have a quality of its own and this inevitably influences the feeling of the drawing. Paul Klee (1879–1940) talked of 'taking a line for a walk' and was very aware of its intrinsic energy. By experimenting with different drawing media, it can soon be seen that even an abstract line has a character of its own. A line drawn with a stick of charcoal will have a vigour and urgency that cannot be suggested by a delicate pencil.

Most people see drawing as a form of visual record or a type of documentary. This categorization

encompasses everything from the briefest of sketches, intended only to note an idea for later development, to finished studies. Michelangelo made hundreds of drawings to investigate the figure in different positions and from different angles. Despite the fact that these drawings were part of the process of painting and sculpting, they are also works of art in themselves. Similarly, Rembrandt, Rubens, Raphael and many others made numerous studies of the head. While these may have been made with particular paintings in mind, the studies demonstrate powerful artistic curiosity. This type of drawing is a way of finding things out, of seeing how they look, of discovering how the quality and

intensity of a line can be used to interpret the texture of surfaces.

However, in order to understand more about the nature and power of the line, it is worth examining different types of drawing where the line takes on a special significance beyond its capacity to define forms in space. Cave drawings, picture languages and the stylized drawings of children all help to demonstrate the more expressive aspects of the line.

The oldest works of art that survive are drawings. Examples in France and Spain dating back to the Paleolithic period include animal figures drawn onto the walls of caves. These drawings were probably made with lumps of earth or clay that may have contained

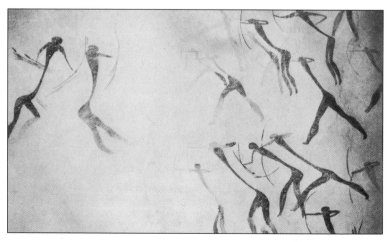

Above: The earliest surviving works of art are pictorial. These ice-age paintings were found in the caves at Lascaux in southern France.

traces of minerals such as iron oxide or may have been burned to enrich the colour. The exact purpose of these drawings is not known, but it is assumed that they were part of the ritual of the hunt and it has been suggested that by marking the image of a creature on the wall, primitive people felt that they had gained power over the beast or tamed it in some way.

Drawing has also played a large part in the development of the written language. Some scripts today, such as Chinese, still retain a pictorial quality. Early writings, such as ancient Egyptian hieroglyphics, closely resemble comic strips. The Egyptians made little distinction between their paintings, which were really coloured drawings, and writing. The purpose of their tomb paintings was to convey information, not to create the illusion of reality. Egyptian sculpture and some of the less formal paintings show that they were quite capable of imitating real life, but this was not their principal intention.

In the light of these 'primitive' examples, it is interesting to trace the development of drawing ability in children. When infants first begin to express themselves using paper and pencil, there are certain typical stages through which they pass. The basic urge to draw appears to be instinctive; children with no paper or pencil will use sticks and stones to scratch marks on the ground. Not until they are much older does it occur to them that the marks they make should bear any resemblance to reality. A young child draws simply to make a statement. Nevertheless, children are selective and everything that is represented has a special significance.

Many studies have been made of the early years of a child's development and it has been suggested that the first thing a child learns to distinguish is the face of his mother. Later, the overwhelming fascination of this face is represented in simple terms when the child begins to draw. First pictures of mothers often consist of a large circle containing smaller circles indicating the eyes and mouth. The power of this image is such that at this stage the child will often make no attempt to include the body.

The next typical stage is the drawing of the figure where arms and legs are shown radiating from a circular head. Again, the elements that are included reflect their importance at this point in the child's development. Someone who has only recently learned to walk will be very aware of the function of the legs. The child records this milestone in his development by acknowledging limbs on paper, usually with a single pencil line,

but often culminating in big feet. Similarly the hands, over which the child has only imperfect control, may be disproportionately large in his drawings.

Like Paleolithic men making cave pictures of animals in order to assume control over them, children attempt to reinforce their identities through drawing in this way; they can exercise control over the environment in the act of re-creating it. As children become more aware of surroundings, other elements begin to appear in the drawings. Sky and ground are often represented by two lines, one above and one below the figure. Sometimes a single line is used that completely encloses the figure in a secure mandala, a feature that has been observed in the drawings of children of all races, both primitive and civilized. The implications are fairly obvious: the child is using the line drawn around the figure as a symbol for security, a protection against the unknown.

The way in which children draw figures in action is often interesting. A running figure may be drawn with legs that are no different to those of a standing figure, except for the fact that they are twice the size. In a manner reminiscent of medieval painting, the child is drawing attention to the function of the legs by enlarging them out of proportion to the rest of the body.

It is not always easy to interpret children's drawings except by being present while they are being made. Children usually draw attention to the significance of marks they make, although they may later forget what the marks were supposed to represent. Usually they do not take more than a few minutes to complete each drawing and once it is finished it will be set aside and forgotten. It seems as though the actual process is of far greater importance than the result.

It is only as the child grows older

This drawing (below) by a child of two and a half years shows the figure contained in a mandala form, the age-old instinctive way of representing the human figure, perhaps a security motif. The child has balanced the design by adding arbitrary squiggles.

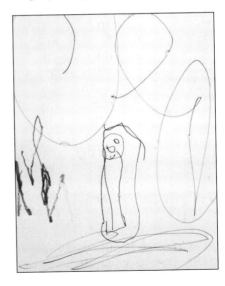

that he begins to want to make drawings that are less subjective and more a literal imitation of the visual world. This comes partly as a result of observations of other people's drawings and paintings. It is also at least partly due to the expectations of adults who will ask, 'What is it supposed to be?' and will even call upon the child to justify the contents of a picture. It is then that it becomes important that it should fall within the conventions accepted by the adult world. A child who has quite happily portrayed his mother with a frizz of red hair when really it is straight and dark will suddenly see the drawing is wrong. At this stage, the naïveté of the child's drawing begins to be replaced by sophistication, but many artists have tried to recover the quality of children's drawing in their own work.

Just as when children draw they are not seeking to imitate reality but to say something about it, so artists may choose to concentrate upon a particular aspect of their subject matter. If they are interested in facial expressions, then their drawings will not be the same as if they were interested in investigating anatomical features. At its most extreme, this preoccupation leads to exaggerated caricature.

Drawing is a highly subjective activity; the way in which different

This is a more developed drawing (above) by a thirteen-year-old. It shows a strong awareness of composition and an acute observation of everyday things, such as the necklace, lamp and bottom of the table. A good attempt has been made to depict the fingers realistically.

people draw is as recognizable as their handwriting. The finished work is partly an objective record of what artists see and partly a record of how they feel about what they saw. This instinctive response to the visual world is as different and various as there are individuals; this is one reason why there is always something new to draw.

Perspective and the Figure

Combine careful observation and the application of the rules of perspective to achieve a sense of diminution and scale often vainly sought in figure drawing.

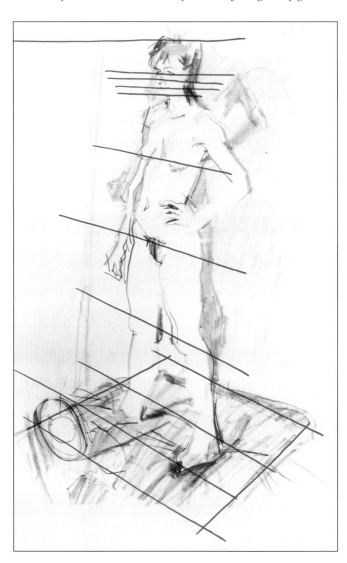

When interpreting the figure, whether posed or in action, not only should cognizance be given to the general features and details of anatomy, but there are other factors that should also be brought into account. Important among these is perspective. In figure poses, for obvious reasons, distance from one part of the body to another is of necessity limited; the maximum travel from a point in the closest foreground to that at the greatest distance from the eye is unlikely to be more than the distance between outstretched hands above the head and the feet – about seven feet. Nevertheless, when drawing a figure, the rules

of perspective must be employed to suggest depth, solidity and balance. At its simplest, this merely involves the relationships between the angle of the feet, hips and shoulders, plus their relationship to those angles of

In the single figures shown on both the opposite page and at right, the need for an assessment of the perspective of the figure drawing can be seen. To set the figure on a solid base, it is often helpful to sketch in a platform on which the model can stand or sit, to which the angles of the body can be related. The angles through the shoulders, hips and feet demonstrate the effects of perspective. The eye level of the artist will coincide roughly with the eyes of the standing model.

the top of the head. The important thing is to treat the figure as just another solid existing in space to be interpreted according to the established conventions of making pictures.

It is always important to draw a firm platform for the feet of a standing figure or, in the case of a seated model, for the thighs and buttocks. One method is to draw an enclosed platform on the floor plane – as though the figure were standing on a smaller dais. This can be an aid to drawing the figure, for to be able to relate the points of the form to an edge in space makes it easier to establish the three-dimensional nature of the figure.

Now, from the angle set by drawing an imaginary line between the soles of the feet (assuming them to be well poised), one can begin to set up the perspective of the pose. The eye level of a figure drawing

Opposite page: When more than one figure is involved, again it is useful to establish the floor plane. This helps to keep figures from appearing as though they are on hills or standing in holes and enables them to stand or sit on the same plane as their fellows. Many figure artists make elaborate ground plans, as did Leonardo da Vinci, drawing in eye levels, vanishing points and other structural lines necessary for the depiction of space, only to obliterate them later in the process of developing the sketch into a painting.

will not generally vary too much, as we tend to meet most people at our own eye level. Lines will converge from above and below, so the shoulders will most likely be slightly below, whereas the top of the head will be slightly above eye level. The feet, knees and hips, however, will be well below and the angle of them, relative to the other features, will therefore differ as a result. In cases of more extreme movement, when for instance the legs are placed wide apart, the perspective construction will be more marked, but in all interpretations of the figure such descriptions of space must be located.

In portraiture, another very interesting use of perspective can be employed. Because all the features of the face are set on a semicircular plane, the lines as they converge must allow for it. The mouth lies on a further semicircular form, raised above the main facial structure, so careful observation is essential.

When several figures are involved in a composition or in association with other features, the use of perspective is important. The joy of relating foreground details with distant form is to be experienced and exploited – it brings visual excitement and originality to a theme. An eye in full foreground can be the same size on the picture plane as a full figure in

the distance. Many great painters have used extremes of scale to express depth and enhance the rhythmic composition, so the eye may see swirls and convolutions on the picture surface, going on to penetrate into middle and deeper distances. Frans Hals's group portraits are fine examples of this technique.

In this example, the features of the face are symmetrical, so when the face is seen at an angle, lines drawn through the eyes, base of the nose, mouth and chin should all recede to a vanishing point far in the distance. Careful observation is needed when drawing a portrait because the effect of diminution can greatly alter the character of a person. For instance, in the drawing here, the eye will appear very slightly narrower, allowing for the effects of foreshortening.

Geometric Composition

So many of the most exciting pictures on the walls of galleries or churches are constructed in such a way as to lead the eye on a journey of lyrical convolutions, through and across the surface. What is often not realized is that these compositions have a basic geometric 'scaffold' underlying the work – sometimes based simply on the triangle but often of a more complex nature – devised with great care to promote a feeling of stability.

A geometric foundation to a composition is visible to the observer through compositional lines. These lines are formed not only with gestures made by figures, but by the angle of a figure, the shape of buildings, trees or other elements of the composition, each contributing to a compositional line or part of a line. Out of this order can readily spring rhythm where composition lines, apparently unrelated, can be traced from one energetic movement to another, taking the eye on to other, often opposite, rhythms.

In such compositions, care must be taken not to lead the eye too violently off the edge of the picture or even towards the edge so that the viewer's attention is precipitated off the picture surface. Rather, the eye should be enticed back into the composition, via a circuitous route perhaps, but back to complete the viewing of the work. It is interesting to investigate and analyse the geometry behind such compositions.

First, we could take the simplest geometric structure – an equilateral triangle set symmetrically within a rectangle. Examples of such a composition abound, particularly in Renaissance paintings of the Madonna and Child. In its simplest form, the apex of the triangle sits in the centre of the top edge of the support. The main features of the work are then contained within the two diagonal sides, the bottom of the support forming the base line of the equilateral triangle. This construction gives the painting a strong sense of calm and dignity, one that incites no argument but gives a classical balance and unity, without excitement but with satisfaction. But it is also rather limiting and predictable and, even when the triangle changes its characters and takes a more Gothic (pointed) form, the same results apply.

This basic 'scaffold' was often enlivened, therefore, by introducing other rhythmic lines within the lines of the triangle. Alternatively, asymmetry can be employed by moving the apex of the triangle to

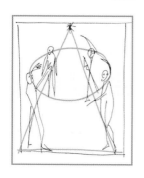

The sketch above shows how symmetry gives a solid base to a composition and also demonstrates how the eye can be invited into and around a picture, through compositional lines based on geometric shapes. In the West, we tend to read a picture as we do a book – from left to right. An introduction into the picture space can be affected, therefore, by a diagonal gesture or line, from the left-hand side up into the picture.

The sketches on the left show how more complicated geometric compositions can be contrived.

one side or the other, dividing the rectangle of the support in a more

interesting way. This means there is still an ordered underlying

structure, but it affects the mood of the composition in a more dynamic way. More interesting use of the triangle as the skeleton of the picture can be made, for example, by using two or more interrelated triangles – side by side, overlapping or integrated. And these triangles are not necessarily sitting solidly on their bases, but sometimes they are inverted or superimposed on other geometric shapes within the picture.

For many subjects, such a construction is suitable and no variations or adjustments are called for. But other subjects will demand other solutions.

Painters plying their trade in Italy in the fifteenth century created wonderfully complex skeletons upon which to hang the flesh of their pictures. A fine example is Piero della Francesca, whose compositions bear analysis. From the simplest, most obvious primary shapes – squares, rectangles, circles – through ever more complex subdivision, they can be overlaid with a rich mesh of lines, each dependent upon its neighbour, each indispensable to the unity and totality of the work. Indeed, this process of discovering a geometric structure beneath the surface leaves us with a perfectly balanced abstract painting in which the interplay, the intersections and the conjunctions combine to create a sense of completeness. In the case of Piero della Francesca, this mathematical structure was an essential part of his art, indeed of his life, but it never dictated a rigid, unfeeling result; rather, it served to free him to paint his images with great sensitivity and subdued passion.

It is by examining the paintings of others and experimenting ourselves that we can learn what suits the demands of the subject. All art benefits from intelligent risk and exploration and the sense of satisfaction achieved through balancing the different parts, mathematically, intuitively or by a combination of both, is basic to good picture-making.

Above: An example of the mathematical base for the painting *Baptism of Christ* by Piero della Francesca. The strong verticals are balanced by the compositional lines of a circle centred on the dove, describing the top curve of the frame, around to St. John's left arm and the top of Christ's loincloth.

Rhythm in Comparison

Another way to give your composition structure is through rhythm. The eye is led across the picture from one point to another by curving, curling, twisting lines of the surface pattern. And often not merely across but into the picture, too.

This form of composition inspires a feeling of movement, urgency or violence. It is more precarious than the solid reliability of the geometric kind, but suits some work much better.

There are many fine examples of such an approach and the excitement they engender is the essence of much baroque art. For such picture-making a preparedness to take risks, delete, adjust and correct – not once but perhaps many times – in the early structural stages is essential. To rely on an emotional response to the needs of the work and discover, through a dialogue with the picture surface, the best solution is a risky business. The rules are not so rigid here but they remain, nevertheless, basic tenets that must not be denied.

To lead the eye from any given point in the picture demands a line of interest and inner strength, not a flaccid and weak one; any such implied line must interrelate with all the other lines, whether implied or described on the surface. Such rhythmic lines need not, however, be so full in curve or circular in motion that the picture surface appears to be alive with writhing snakes or like ancient trees in a grove. Better that the lines vary, some being curvilinear and anxious, some slow in movement, others giving contrast by simply being straight. All such lines will marry on the picture surface to bring a rich composition the strength of interdependence and the desired sense of unity and completeness.

The Dutch painter Peter Paul Rubens (1577–1640) favoured this method. In his paintings there is a characteristic sense of sweeping, swirling rhythms. The eye is led from any one point across a complex interplay of circular, ovoid and S-shaped lines until they unite, only to set off again. They are full of movement and energy.

In analysing the work of such painters, look at the edges of the picture. Such compositions need room to breathe – to distance the urgent, tumultuous forms from the static edges. Such a design, however, needs the stability of the sides of the support, so care should be taken to acknowledge them by reflecting the shape of the support in the composition.

Klee made the surface of his drawings and paintings pick up rhythms too, but, in contrast to Rubens, in many cases not languid and slow-moving but staccato and urgent in feeling. Indeed, to lead the spectator into the magic world of the picture, and excite an emotional response while doing so, is one of the most satisfactory things in all art language. There is obviously less danger of precipitating the eye off the edge in such compositions, for in each part of the work, not one rhythm, but several major and minor ones might be employed. In such cases, the character of the lines is likely to be straighter, the overall feeling more Gothic – the beat of the drum rather than the melody line of the flute.

To combine the several methods discussed – those of geometric understructure, rhythmic lines and staccato marks – within one composition can lead to a satisfactory picture.

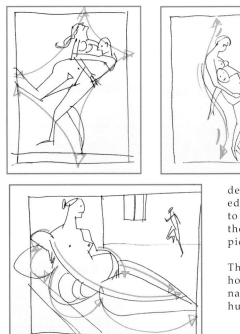

The three sketches here are a few examples of energy being expressed through surface rhythms. They also demonstrate how useful the edges of the support can be to anchor lines and make them easier to locate in the picture space.

The picture at left shows how the eye follows the natural rhythms of the human form.

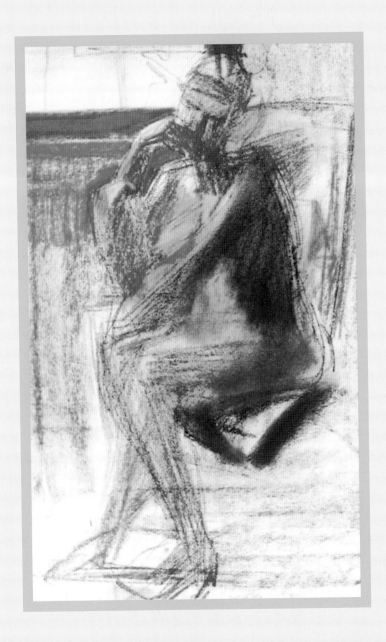

DRAWING MATERIALS AND EQUIPMENT

The materials chosen for making drawings will vary according to the intentions of the artist and the nature of the subject. They will also vary because each artist will develop his own style and prejudices, preferring one method of applying tone, line or colour to any other.

Only by experience will you learn which method or material suits you best; by trial and error you are likely to discover the ideal medium, and unexpected combinations can often provide new possibilities.

The surface itself, as well as the tool used to make marks, is a factor to be considered. A completely different effect can be achieved when using the same instrument on smooth or rough paper. On one drawing, part of the surface can be made rough by rendering, or a variety of pencils, pens or chalks may be combined.

Develop a system for organizing your materials, both in your studio and when working in the field, so that nothing is lost or left behind when you most need it. As well as the support and the instrument to be used, you will have to remember erasers, perhaps a flat blade for removing unwanted passages by careful scraping, and some method of fixing the finished drawing. Several proprietary brands of fixative are available, but if you do not want to have to carry this with you, perhaps when travelling or drawing outdoors, sheets of thin paper such as bond can be inserted between the leaves of a sketchbook.

TIP
USING A MAQUETTE FOR PLANNING

Artists use maquettes, or mannequins, when a live sitter is not available, when a pose might be difficult or uncomfortable to maintain for long periods, or to try out ideas for poses to make several figures relate in a composition. The simple elbow, wrist, knee and foot joints of maquettes move on the same planes as human ones and can be manipulated into lifelike positions, but there are no faces, fingers or toes, so these must be added from life.

Pencils and Other Drawing Media

The word 'drawing' suggests to many a work executed in pencil, but a variety of tools has always been available and this selection is increasing so that the draughtsmen of today can choose from a very wide range of materials.

Within the field of pencil drawing itself, several grades of pencil can be used in one piece of work, letting the qualities merge on the surface in order to achieve a rich interplay of line. Many other materials can be used to extend the visual range.

One factor to be taken into consideration, as well as the type of effect you want to achieve, is where you plan to work. For instance, if you want to make detailed studies in a small country church, miles away from roads, practical problems of weight and ease of carriage will be uppermost in your mind. In this case a clutch pencil, the modern equivalent of the propelling pencil, would be a particularly suitable tool. Leads can be changed easily according to the degree of softness required, so all that need be carried is one pencil, several leads and a pocket sketchbook.

PENCIL

The most common instrument used for drawing is the pencil (from the Latin word *pencillus,* meaning 'little tail'). Made originally from graphite, first discovered in Borrowdale, England, in the sixteenth century, it was not until the eighteenth century that pencils developed into approximately the form we know today. These used a core made of a compound of graphite, clays and other fillers. The cores were inserted into grooved wooden cylinders and thus the modern pencil was born. Nowadays synthetic graphite is used, enabling the manufacturer to more closely control the pencil's relative hardness or softness. When graphite was first discovered it was mistaken for lead, giving rise to the name 'lead' pencil that has persisted to the present day.

Pencils are graded by the 'H' and 'B' systems. H through to 8H indicate increasing hardness of lead, whereas B through to 8B denote increasingly soft cores. It is important to experiment with a wide range of pencils. Their characteristics may vary according to the paper used. A hard pencil, for instance, makes a fainter mark on a smooth, coated paper than on a coarsely textured one. Similarly, a very soft pencil, say a 5B, will make

an intensely dark, coarse and rich line on textured paper, so much so that marks may prove difficult to control. Often the best way to exploit the pencil fully is to combine several different grades. Paul Hogarth (1917–2001), for instance, was a leading contemporary artist who demonstrated the use of various grades within the same work.

Care must be taken when sharpening the pencil, particularly with the softer leads. Rotate the pencil and slowly shave off the wooden casing with a sharp craft knife or single-edged razor blade. Use a sandpaper block to finish smoothing down harder pencils. Some uses will not necessitate very fine points and a blunt end will be better.

MASTERS OF PENCIL

Fine pencil drawing has been a feature of art for many years and much can be learned by studying the work of leading artists both past and present. The early forerunner of the pencil was silverpoint, a sharpened stick made from an alloy of lead and tin. The study of a man in a helmet by Leonardo da Vinci shows a refined technique comprising many fine shaded lines netting across the paper surface to record the image. Various pressures are employed to give due emphasis and stress;

sometimes the surface seems to be almost caressed. Contrast this with the vibrant figure studies of the great French sculptor Auguste Rodin (1840–1917). Here the line seems to be a continuous tracing on the paper, full of energy and conveying somehow a prediction of the next intended movement.

Jean-Auguste Ingres (1780–1867) used long, clear lines travelling with apparent inevitability alongside careful, shaded tonal details of character in the faces and heads.

The line has here lost that instantaneous quality associated with the work of Rodin and seems to have moved a long way from a mere study; the drawings exist as fully qualified works in their own right. Other pencil drawings show a sense of searching towards a greater

comprehension of the subject. The nudes of Henri Matisse (1869–1954) show the line being pared down until the most simple, economical contour line will bring the sheet of paper to vibrant life, an approach that is virile and risky.

Right and opposite page: Graphite pencils are available in a wide variety of degrees of hardness or softness, from 8H, which is very hard, to 8B, which is the softest lead. In order to illustrate the differing effects, the appropriate pencil has been used to draw each of the selections shown at right and on the opposite page, so that the hardest, 8H, appears much fainter than the dark, smudgy effect of the softest, 8B.

PENCIL EFFECTS
Different combinations of pencil and paper produce a wide range of effects. Below are some examples of these.

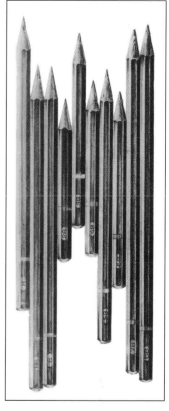

A fairly soft pencil (4B) creates a graduated tone on a moderately smooth paper.

This effect is achieved by drawing with the reverse end of the pencil to create indentations, then shaded.

The same 4B pencil used on rough paper gives a much less even result.

Here, 2B lines have been partially erased.

Charcoal

Charcoal is made of sticks of wood, often willow, burned to carbon. Various grades are available, ranging from hard to very soft, and the latter particularly need to be fixed to the surface of the paper on completion of the drawing. This is normally done by the use of a proprietary brand of fixative.

Recent times have seen developments and changes in charcoal, as in so many other materials. Charcoal pencils, containing compressed powdered charcoal and a binding agent, offer more control and a cleaner instrument with which to work. The density of mark will vary according to the proportions of pulverized charcoal to oil (or wax); a softer pencil contains more binder, a harder one less. In general a toothed paper or board is most suitable for use both with sticks and pencils.

Left: Compressed charcoal pencils (A), can be either soft, hard or medium. Charcoal sticks come in varying widths; shown here is a thick variety (B).

Left: Compressed charcoal also comes in stick form (C). Medium charcoal stick (D).

CHARCOAL TECHNIQUES

Charcoal can be used to good effect for strong and vigorous linear works and it is especially suitable for making tonal drawings working from the darks, a technique in which the surface of the support is covered with a consistent layer of powdered charcoal forming a flat, mid-grey tone. From this surface, by the use of a kneaded or putty rubber, the lighter parts of the design are provisionally picked out, leaving the grey sheet punctuated with patches of white. Into this

E

Left: Thin charcoal stick (E).

beginning can be introduced the positive marks, using lines and smudges of charcoal. Development through the consolidation both of the negatives (the wiped-off areas) and the positives allows great scope for adjustment and even major correction.

One of charcoal's prime advantages over other drawing media is this capability of being changed. The drawing can remain in a state of flux, with many obvious advantages. Degas tended to use charcoal in a similar way to chalk or pencil, enclosing the figure forms by firm, positive strokes, but exploiting the material's versatility by rapid indication of varying areas of tone. Matisse made figure drawings in charcoal combining line with the soft smudges, left as ghostly traces, of corrections having been made. Picasso, during the Cubist period, found charcoal a sympathetic medium.

F

Above: Powdered charcoal (F) is available for use with a stump.

Here are some examples of charcoal techniques.

Use fine, hatched lines to build up an area of graded tone, working in one direction and varying the pressure.

Loose cross-hatching is an alternative method of applying texture and building up tonal areas.

Lay areas of tone with the side of the charcoal stick and cross-hatch over the top for a richer texture.

Use a finger to spread charcoal dust evenly over the paper to vary the tone.

Create areas of pattern and texture by rubbing lines lightly with a putty eraser without erasing them completely.

Work lights by using a soft putty rubber. A clean piece will erase charcoal completely.

Use a charcoal wash technique to soften and spread the tonal areas. Work gently with a soft brush and clean water.

Highlights can be added by using a white chalk or pastel. This is particularly effective on tinted paper.

Pastels and Chalk

Colour is used in drawing both to arrest a memory and to enliven the picture surface, but it can also be used to describe the world as seen through the artist's eyes or to propose schemes for works in other media.

PASTEL

Pastel drawing was at its height as a popular medium for portraits in the eighteenth century, but since that time it has been used by a number of artists, either as a unique technique or in conjunction with other materials. Traditionally, pastels are made from powdered pigments mixed only with sufficient gum or resin to bind them

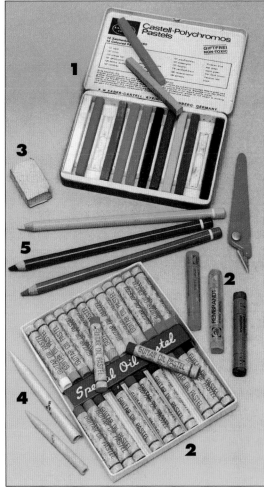

Pastels (1) come in two types, hard and soft. The soft type tends to crumble easily. Oil pastels (2) are made from a coarser pigment and have an oil binder added; they are useful for mixed-media drawing. A putty eraser (3) and selection of torchons (4) are useful for spreading colour or obtaining highlights and pastel pencils (5) can be used for detailed work. Use a knife for sharpening oil pastels but work carefully in order to avoid breaking them. Ordinary pastels should be sharpened by rubbing them gently on fine sandpaper; in general they are more suitable for delicate work than oil pastels.

into stick form. Pastels tend to be softer than pencils or chalks; they are still, however, defined according to grade, depending on the amount of gum used in their manufacture.

The primary advantage of the medium is its immediacy of effect, it being necessary only to rub the stick over the surface for it to release the characteristic fresh pure colour. This distinguishes pastel from oil or other paints. The support used is often pastel paper – a surface made with pastel drawing specifically in mind and usually coloured. If the available ground colours and surfaces prove unsuitable for the portrayal or design intended, it might well be preferable to prepare the surface yourself. This can be done by applying watercolour, perhaps with the addition of a little gum or egg white. Acrylic paints can also be used, giving an agreeable and controllable texture; making selected areas of the surface textured assists in the quest for variety and richness.

PASTEL TECHNIQUES

Diagonal hatching can be laid in by using the side of the stick of pastel. The thickness of the lines depends on how firmly you press.

By rubbing the hatched lines with a fingertip, the colour can be spread and a hazy effect achieved.

Use the side of the pastel and press lightly in order to obtain crisp, fine lines.

Working across these lines in the opposite direction results in a cross-hatched texture, one of the best ways of achieving tonal and shading effects.

Lay an area of colour with the blunt end of the pastel by working along the grain of the paper in one direction only, being certain to use firm, even pressure to achieve an even tone.

Peel back the protective paper and hold the pastel flat against the support to obtain a broad area of grainy colour.

Use a kneaded rubber to create highlights and to lift off colour and achieve paler tones.

Make brisk strokes across the grain of the paper with the blunt end of the pastel in order to create a stippled effect.

CHALK

Chalk is a harder medium than pastel, pigments being mixed with wax or oil to make them usable in stick form. As well as silverpoint and, later, pencils, chalk has long been used for drawing. Many of the drawings best known to us through reproductions, by Michelangelo, Andrea del Sarto, Henri Toulouse-Lautrec and Antoine Watteau, all made brilliant use of the medium. Some used black chalk, some red and others mixed the two and even used white to bring out highlights.

MASTERS OF CHALK

A fine example of the traditional techniques developed in the High Renaissance is the self-portrait by Andrea del Sarto (1486–1531), shades of tone being suggested through a great number of lines, laid side by side at a forty-five-degree angle. Toulouse-Lautrec (1864–1901) used the chalk quite differently, the results showing a mixture of strong linear description and areas filled with flat grey or black suggesting colour patches. Watteau (1684–1721) had the rare fluency that allowed him to take on all manner of problems in his drawings, usually mixing black with red chalk and manipulating the visual world to create his own romantic visions. Käthe Kollwitz (1867–1945) brought a disturbing power to her studies of peasants.

Georges Seurat (1859–91) was another inventive artist whose use of chalk perfectly matched the philosophy of his art. The sense of quiet monumentality, achieved through the organization of large areas of tone, discarding the more traditional language of line, is developed further in the artist's few large paintings. Alberto Giacometti (1901–66) worked to rediscover form, even to invent his own from the evidence before him. The fatter, fuller feel of chalk in Michelangelo's Sistine Chapel studies carries no less intensity but exploits fully that other quality of the medium, the broad sweep of the line. From the drawings of ballet dancers by Edgar Degas (1834–1917), through the bullfight scenes of Francisco José de Goya (1746–1828), to landscape studies by Claude Lorrain (1600–82) and the portrait of Tudor times presented by Hans Holbein the Younger (1497–1543), the stick of chalk offers a wide range of possibilities.

PASTEL EFFECTS

LAYING AN AREA OF TONE

1. Diagonal hatching can be laid in by using the side of the stick of pastel. The thickness of the lines depends on how firmly you press.

2. By rubbing the hatched lines with a fingertip, the colour can be spread and a hazy effect achieved.

3. Use the side of the pastel and press lightly in order to obtain crisp, fine lines.

4. Working across these lines in the opposite direction results in a cross-hatched texture, one of the best ways of achieving tonal and shading effects.

ADDING DETAIL WITH A PASTEL PENCIL

Pastels in pencil form are easily sharpened and therefore suitable for detailed work.

ADDING DETAIL WITH CHARCOAL

Sharpen charcoal by rubbing lightly on sandpaper and use the point to make strong, crisp shapes.

LIFTING PASTEL WITH A BRUSH

Excess colour can easily be removed by brushing gently with a soft paintbrush.

Erasers and Other Equipment

Before the eraser as we know it today was in common use, a piece of bread worked between the fingers, or even a feather, was often used to remove pencil and chalk marks. Rubber itself proved to be more effective than bread. Nowadays, oil by-products are used to make synthetic erasers, and they come in a number of sizes and textures.

Traditional burnishers comprised a handle, not unlike a brush or pen handle, with a piece of agate or other semiprecious stone attached to one end. This module of stone was rounded and smooth and was used across the surface in a caressing, gentle rubbing, followed by firmer, stronger strokes to polish the surface. If such an implement is not available, then many other things make excellent substitutes. A softly rounded plastic object, for instance, or the grease-free back of the fingernail will burnish satisfactorily.

Erasers can be exploited in unconventional roles.

Electric erasers can be used to pick out faults among otherwise acceptable work, while softer erasers can erase a larger area without damaging the paper surface. The putty or kneaded eraser is used in the positive/ negative technique recommended for charcoal. Although the eraser becomes dirty with this technique, experience shows that a little manipulation in the fingers cleans it quite effectively and it can be used again and again before finally becoming impregnated with charcoal dust.

EQUIPMENT (opposite page): Erasers are now made in a variety of forms to suit the demands of different drawing media. A bread eraser (1) was the earliest type, largely superceded now by kneadable putty erasers (2), which can be used in a solid mass or drawn into a pointed shape for greater precision. Soft erasers (3) come in a number of shapes and sizes and the art eraser (4) is specially composed to have nonsmudging properties. Plastic erasers (5) give a clean, sharp edge and are suitable for erasing pencil, ink and graphite. Eraser pencils (6) and cores (7) can be used with accuracy and fibrasor (8) will rub out drawing ink, which is often difficult to correct. An electric eraser (9) is also marketed and the core in this can be changed to suit work in ink or pencil. An ink eraser made particularly for designers (10) may be useful in a drawing studio.

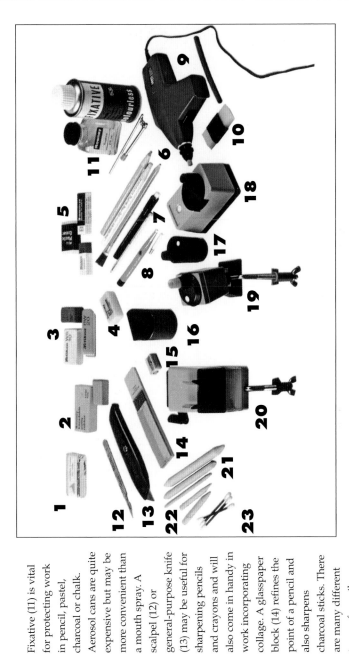

Fixative (11) is vital for protecting work in pencil, pastel, charcoal or chalk. Aerosol cans are quite expensive but may be more convenient than a mouth spray. A scalpel (12) or general-purpose knife (13) may be useful for sharpening pencils and crayons and will also come in handy in work incorporating collage. A glasspaper block (14) refines the point of a pencil and also sharpens charcoal sticks. There are many different types of pencil sharpeners, from the most simple (15, 16) to clutch models (17, 18) that hold the pencil steady. For studio work a table sharpener (19, 20) fixed to the tabletop can be a convenient device. Stumps (21) are resistant sticks that are also used to spread chalk, charcoal or pastel when shading a broad area and torchons, or tortillons (22), made of heavy rolled paper, serve the same function. Cotton buds (23) can also be used but are less precise.

Paper

Paper is often the critical factor in a drawing and this is true no matter what the chosen medium. Although not the only support available, paper is far and away the most common, for the good reasons of cheapness and portability. Variations in colour, texture, weight and surface make it appealing for most uses.

HAND- OR MACHINE-MADE

The manufacture of paper has been a highly refuted skill for centuries and although most is factory-made today, there remains a core of handmade papers for the use of artists. The raw material for such papers is linen rag that is pulped with some other substances, great care being taken to remove impurities, and is laid out on drying racks. The correct side for drawing use is sized and is easily recognized from the manufacturer's watermark or the texture, the reverse side retaining evidence of the fine mesh upon which it dried.

Drawing papers are made by machine in three types, hot-pressed, not and rough, the texture coarsening in that order. Hot-pressed (or HP) is much used for pencil and for pen, ink and wash: its surface is relatively smooth but not completely so. Not, short for 'not hot-pressed,' has a more textured surface and a medium tooth very suitable for coarser media such as chalk or soft-leaded pencils. It is excellent for such uses in association with gouache, ink or watercolour washes. Rough is paper with a positively-textured face, especially favoured by watercolourists but also suitable for certain drawing purposes, or for mixed-media works. In general the weight or thickness of the paper will increase with the roughness of its surface. This has to be taken into account when stretching paper; heavier papers need more water and take longer to dry out.

SPECIALITY PAPERS

Charcoal paper is a heavy, rough-textured paper, usually with a coloured finish. With a surface that is not strongly sized, it is good for its advertised purpose, and the crumbly, roughened feel under a charcoal stick is very satisfactory. It does not take kindly to the use of a hard eraser, its surface being easily damaged; the putty (kneaded) eraser comes into its own here.

Pastel papers are available in a wide range of colours, unlike the majority of drawing supports that are usually white, light or at least neutral. The effect created by these coloured surfaces can be seen, for example, in the work of Eric Kennington (1888–1960). In these

drawings and others made during World War I, the pastel is used quickly to model the basic figure or facial forms, contrasting light with dark out of the middle tone of the support. Beginning in this way, the artist gradually fills in other details until evidence of the underlying colour is apparently obliterated. In fact it never is, for the whole work will be influenced on its mood by the colour of the support; learning how to harness this factor will prove invaluable.

Rice papers are very fragile but are sometimes suitable for work in brush or pencil, often of an exquisite nature. All varieties are highly absorbent if watercolour or ink washes are to be used, but in common with all so-called limitations this can be turned to advantage. The manufacture of these papers differs from that of others; vegetable fibres are chiefly used, resulting in beautiful, refined surfaces.

Some recommended papers, suitable for all drawing media, are Kent turkey mill, Ingres papers (in several colours), Saunders, Fabriano, David Cox and De Wint. Others are available both under manufacturers' names and anonymously made as cartridge papers of various qualities.

Boards are on sale in many art stores, their surfaces prepared to make ideal supports for drawings. Many different types are available, usually comprising a sheet of high-quality paper firmly attached to a backing board. These are especially convenient for working outdoors and can be put together by the artist himself. Thin pasteboards, with surfaces ranging from an ivory smoothness to softer textures, are less stable but both cheaper and very pleasant to use. Experiment until you discover the best combination of paper, board or other support and instrument chosen to trace, score or hatch out the drawing.

Below: The range of papers is vast and can be bewildering even for the practised artist; here are just a few samples.

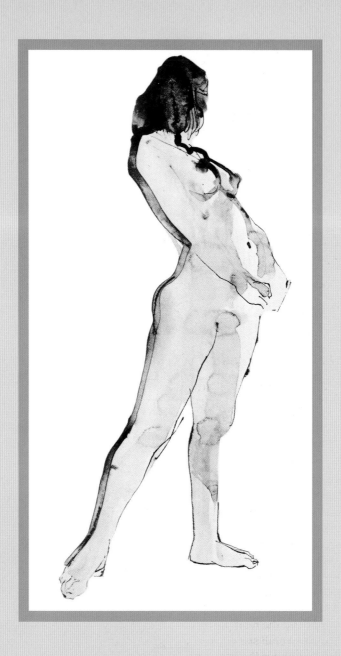

DRAWING THE NUDE FIGURE

There can be few more satisfactory achievements than making a drawing of a figure, attempting to express its individuality, character and style. Never be discouraged if your early attempts seem far from successful; practise is the only route to better results and a classic method of learning is to continue to work at and improve your less than satisfactory drawings, rather than simply throwing them away and starting again.

Familiarity tends to lessen the acuteness with which we observe the physical characteristics of our fellow human beings. If the artist is to capture the individuality of his subject, however, he must adopt a degree of objectivity, even with those he knows very well, and make fresh assessments as he draws. The set of the head on neck, torso on hips and the relationship of the legs to the overall stance need to be seen as though for the first time and then interpreted into pencil, chalk or pen, remembering always that the human body is a machine, albeit infinitely subtle.

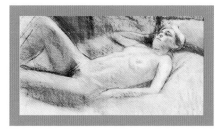

Reclining Nude

Working within a set period of time, an artist will always find certain areas of a drawing or painting taking precedence over others. In this pastel drawing, the head and face provided a focal point and this resulted in a portrait study made at the expense of detail over the rest of the body. The study evolved by constantly relating all the points of the drawing with the head. By placing the figure in a diagonal position, the composition is given more interest.

Even when there is unlimited time, a certain amount of selection is inevitable and indeed preferable when confronted with the complexity of reality. Here, the model is reclining on a number of cushions, each of which is delicately patterned, and behind the figure is a table heaped with plants. Natural light coming from behind the figure provides a further complexity that was overcome by simplifying some areas and strengthening others. The greens reflected on the skin from the plants were given a new source: a simple, blocked-in background. The result shows how different the personal view of a drawing can look when compared with the relatively indiscriminate view through the camera lens.

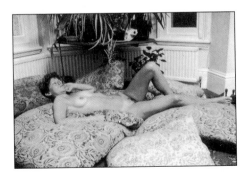

The reclining figure has always been a popular subject. The pose can suggest a sense of calmness and relaxation or invite a frank observation or admiration of the naked body. The artist must pay careful attention to the way the body changes in a horizontal position – the rib cage may be more prominent, the flesh may slacken and the angle of the head can take on a particular importance. Of special interest is the way in which the body is supported. A bed or divan presents a fairly uniform surface, but cushions give a more undulating support, echoing the curves of the figure itself.

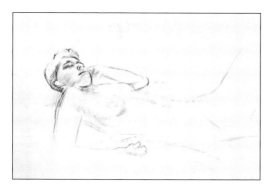

1 The initial stage is a charcoal drawing. The artist begins by sketching the head in a relatively detailed fashion and then gradually works across the paper, delineating the rest of the figure. The figure is placed diagonally on the page at a slightly different angle to the actual pose.

2 The pose of the model changes slightly as she relaxes, the angle of her right arm becoming less acute and her hand moving further down the cushions. The artist takes account of this change and redraws the arm in the new position. Alterations of this nature need not be eradicated. The original lines are faint enough to be incorporated.

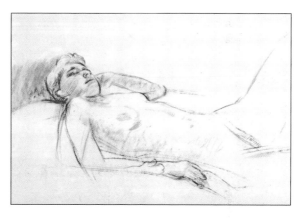

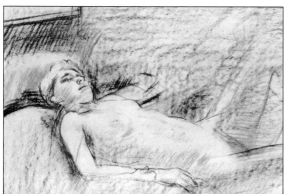

3 The monochrome drawing is not yet complete; the artist adopts a tonal approach to the work and covers most of the paper with charcoal. This creates shaded areas and areas of highlight.

4 A certain amount of pastel has already been added to the basic charcoal drawing. More pastel is now incorporated, the artist restricting his choice to subdued hues in order to concentrate on the tonal qualities. At the same time as the tonal structure is being carefully built up, the detail is beginning to emerge, the figure being strengthened with firmer charcoal lines.

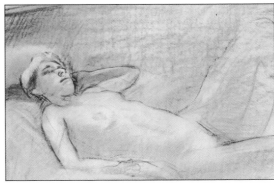

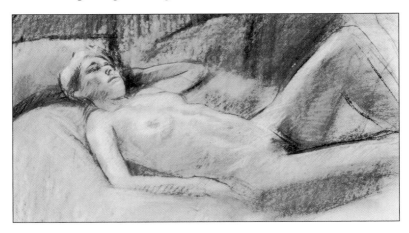

5 In another change of pose, the position of the left leg alters. The model moves her left foot down slightly. This change is correspondingly made in the drawing and the pose is now the same as that which will appear in the finished drawing. The artist does not need to alter his work as the model moves, but small changes of this kind keep the drawing alive and, in this example, better express ease and relaxation. The drawing is now well established – further alterations would be difficult to make. The lighter areas of the figure are modelled and the artist sprays the picture with a commercial fixative, in effect creating a grey underpainting to which more vivid pastel colours can be added.

6 The artist's next task is to add more colour. In this example, colour is not used in a documentary way to make an exact record of the scene, but is part of an intuitive response – the feeling the artist has for the subject. In a similar way to the work of such impressionists as Degas, colour in this drawing works optically, rather than literally. In a sense, each colour that the artist lays down on the paper dictates the next colour to be applied: red is complemented by green, for

instance. The artist has chosen to translate the green of the plants into a more abstract background; the colour spills over onto the figure and the shadows it makes to create a harmony in the whole picture.

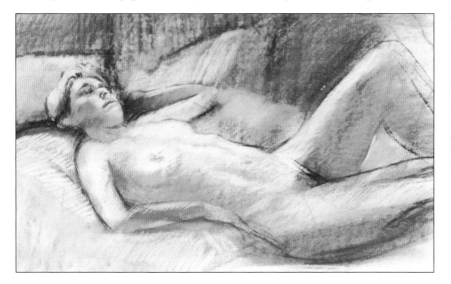

7 A smooth paper has been used for this drawing; unlike paper with a rougher grain, this type of paper retains the vividness of pastel pigments when it is used with fixative and the white background does not show through. By rubbing with the hand, the pores of the paper can be filled in further, blurring the outlines of the drawing slightly, as if it were out of focus.

8 While this quality of softness is effective for merging the background shapes, some reestablishment is needed for the outlines of the figure itself. Film lines are redrawn around the figure using charcoal.

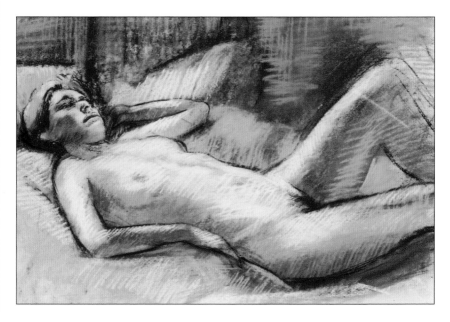

9 The process of applying colour is continued, with lighter shades drawn in over the smudged and blocked-in background colours. Hatching and cross-hatching are especially effective when the overlaid lines are in lighter shades than the background. This method of working to the lights – from dark to light – can result in drawings of great luminosity and with a quality of depth and volume. Fine hatching in white brings out the highlights in the flesh. White should be worked over a definite colour, not a near shade such as cream, or there will be no illusion of depth.

10 Charcoal is also used to intensify the shadow areas, particularly around the head.

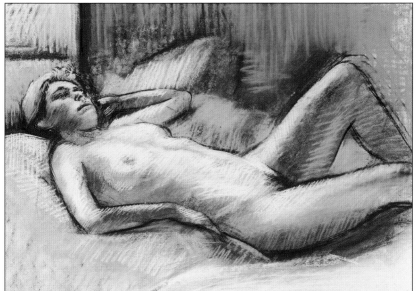

11 The final stage consists of working over the entire drawing to bring all the isolated elements together in one whole unit. Attention is naturally drawn to the pink cushion behind the head, where most of the detail is concentrated. The area above the cushion is worked over in white, to suggest the light source.

Reclining Nude Male

For any artist familiar with the use of a pencil, the prospect of drawing with charcoal can be slightly daunting. Even the softest pencil allows for precision and control and enables the artist to follow sinuous contours with a certain amount of ease.

Charcoal is more abrasive and dramatic and should be used with less concern for sharp definition. Available either in pencil form or in the traditional sticks of varying thicknesses, it can be applied in broad areas, smudged to achieve blurred effects and fixed at intervals to maintain its richness.

For this drawing a grey-green paper was chosen, which provided a mid-tone ground. Papers in dark colours and mid-tones, which can be bought or otherwise made by laying a watercolour wash and allowing it to dry before beginning work, are sometimes chosen so that the artist can 'work to the lights.' A feeling of volume is often more apparent if white chalk is added for the highlights after the drawing has been established in charcoal.

Occasionally the size of the paper proves inadequate as the drawing progresses. In this case the drawing was extended by adding an extra piece of paper to the left-hand side of the drawing to accommodate the legs.

Although a reclining pose is often suggestive of ease and relaxation, this need not always be the case. Here, the slightly uncomfortable position of the male figure exhibits a certain tension, the clasped right hand and angled shoulders implying a latent energy in the form. Attention is directed to the sharp angles and strong shadows, an interest that demands a forceful and immediate treatment. Charcoal is the chosen medium for this drawing, being more direct and less hesitant than pencil. The artist intends to make the figure occupy most of the paper area and has discounted the surrounding area. Only a slight reference is made to context, enough to establish the position of the figure in space, but not detract from it.

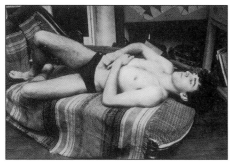

1 Using a linear approach, the artist begins the drawing by concentrating on the head and upper torso, roughly sketching in the main outlines and contours lightly to allow for redefinition.

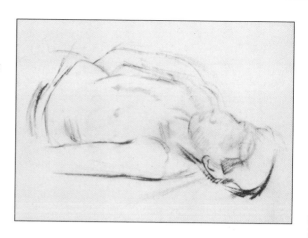

2 Moving across the paper, more detail is added to the face and hair. The artist uses a putty rubber to erase some of the initial lines; the position of the left arm is redrawn and a greater emphasis is placed on the sharp angle it makes. Some shading is added, but the main concern at this stage is to establish the crucial angles of the head, shoulders and arms.

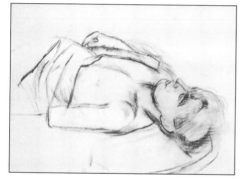

3 Light hatching on the shoulders, neck and torso begin to suggest volume; heavier lines behind the figure fill in the shadow areas.

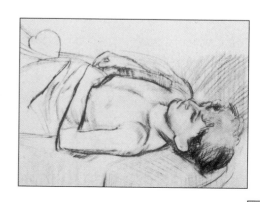

ANATOMY & FIGURE DRAWING HANDBOOK •

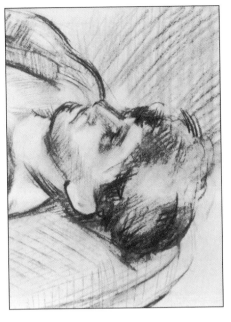

4 A slight movement of the model's head calls for small adjustments to be made to the drawing. The artist again uses a putty eraser to make these alterations, restating the hair.

5 Putty erasers are more suitable for erasing charcoal lines than hard erasers. They are soft and can be moulded to a point to take out small details or make highlights, or they can lighten an area by a tone without smearing.

6 The drawing has been executed on handmade paper with a slight grain, suitable for charcoal. It is grey-green in colour, establishing a mid-tone ground. Highlights are added with white chalk to reinforce the sense of volume in the figure. Adding highlights to a toned ground rather than using a stark white paper is the traditional method of working.

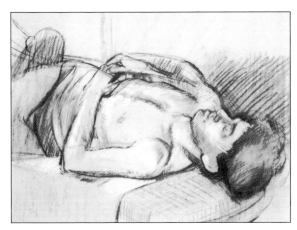

7 Although the addition of highlighting in white chalk has virtually completed the drawing, the artist is dissatisfied with the result.

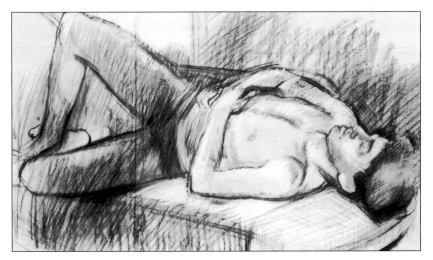

8 As happens quite frequently, especially when making preparatory studies for further work in another medium, the paper's format and the composition look wrong. The artist decides to add more paper to the left-hand side of this drawing to accommodate a representation of the legs of the figure. Once this has been accomplished and the extended drawing is completed, the benefits become obvious. The shaded areas of the legs balance the detail and definition of the head and make sense of the pose. Such alterations are part of a process of investigation and discovery.

Seated Nude by Window

Pastel is a delicate medium, providing a range of brilliant colours and the possibility of working one over others until the result almost looks white.

Chalks are more incisive, harder and produce fine lines, allowing the artist to draw with a vigour impossible in pastel. Both these media allow the artist to work light over dark and make changes or adjustments while work is in progress. Models are likely to move subconsciously or surreptitiously while they are posing, and in order to keep the picture alive, the artist must be able to respond to these changes. Often, a particular pose will not suit a model and he will shift to a more natural, comfortable position. This encourages the creation of a more natural and lively drawing. Such changes need not totally obliterate the original work.

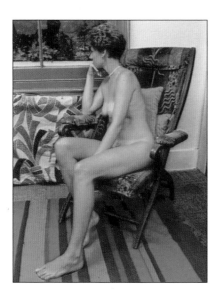

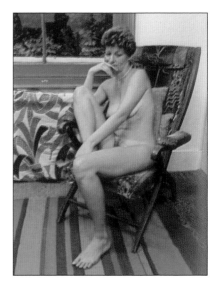

1 The model's first pose, with both feet touching the floor and her head twisted to look out of the window, proves uncomfortable, and despite the initial drawing already being established, the model moves to a position in which she can relax.

2 The two strong lines of her back and her left leg need only slight readjustment and the positions of her neck, head, arms and right leg are changed, although the points of reference remain constant. The first sketches are made in blue pastel, the artist feeling for the pose and quickly relating angles and positions. With some solid work in shades of blue and red, areas of the figure are shaded and the form fills out.

3 The whole picture is worked using a complex system of laying and overlaying colours in different combinations so that the underlayers show through. The result is an overall sense of unity and a subtle feeling for form. Positive background shapes are laid in blocks of colour.

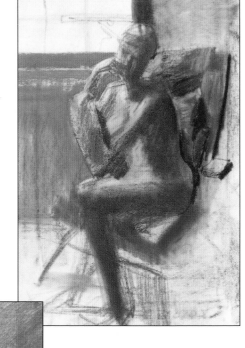

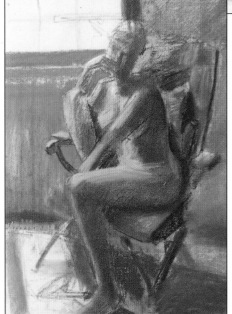

4 The patterns of the background cloth are ignored and a single colour is implied, with brighter pastels used nearer the light source. Using the heavier chalks, earth reds and browns are added to bring out the form of the figure, and build up the arm of the chair over the background bluer.

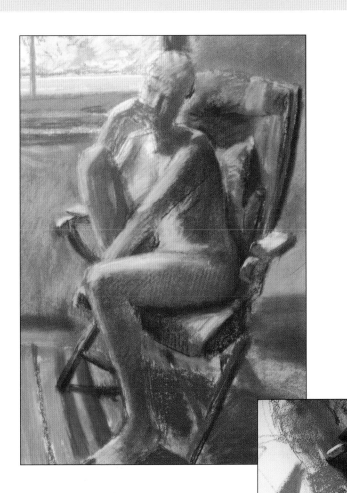

5 Chalks and pastels combine for the bold stripes of the carpet, which provide a tension with the diagonal of the chair. White and yellow highlights in both pastel and chalk, which are illustrated in the close-up (above right), give a strong impression of the indirect sunlight falling into the room. Some of these are blended and smudged into the colours beneath, with further lights added in the final stage. Hatching with contrasting pastels over the already blended and fixed colours creates final subtle shading. Indigos and blues are used over the left thigh and pinks over the chest and left arm.

Figure in Charcoal

Charcoal is a most rewarding artistic medium. It gives a characteristic rich, soft black colour and a wide variety of textures and tones. However, it is powdery and impermanent, while the drawing may soon become messy and uncontrolled if overelaborated.

Observe the subject carefully as you draw, analysing the shapes and tones, and make your marks decisive and vigorous. Do not attempt to be too precise; a stick of charcoal cannot be as carefully manipulated as the fine point of a pencil. The best subject is a strong image full of dense tone and calligraphic line. Use a putty eraser both to take out errors and to draw highlights into the loose, black surface. Fix the drawing whenever a stage of the work is successfully completed so that the surface does not become dull and smudgy.

A charcoal drawing on tinted paper can prove particularly effective, especially if white gouache is applied to strengthen the highlights and round out the forms. Use the paint sparingly and keep it free of charcoal dust or it will look dull and grey, deadening the tonal contrasts and producing an opposite effect to the one intended.

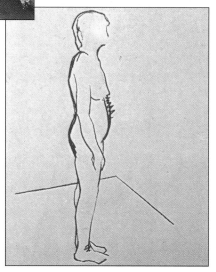

1 With charcoal, draw the outline of the figure with bold, black lines. If necessary, make small corrections or revisions as you work.

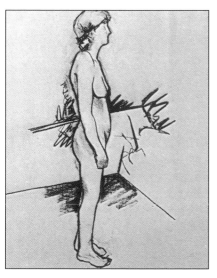

2 Start to develop the tonal structure by spreading the charcoal lightly with your fingers and erasing to make grey tones.

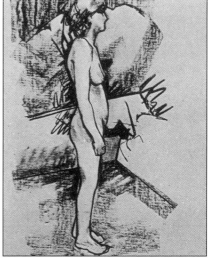

3 Lay in broad areas of grey with the side of the charcoal, using the pointed end to draw into the background shapes with loose, calligraphic marks.

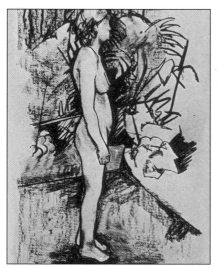

4 Block in small areas of solid black around the figure and strengthen the definition of the shapes and patterns with strong lines.

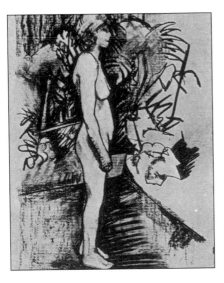

5 Work over the figure, adjusting details and strengthening lines. Use the eraser to lighten greys and bring up white highlights.

6 Apply thin patches of white gouache with a No. 6 sable brush to add definition to the highlighted areas. Let the paint dry before adding the finishing touches.

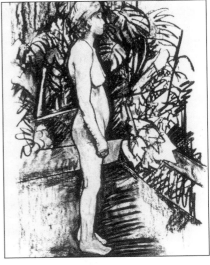

7 With a small brush and white designer's gouache, strong highlights are developed in the figure. The gouache is allowed to blend with the charcoal to create subtle grey tones.

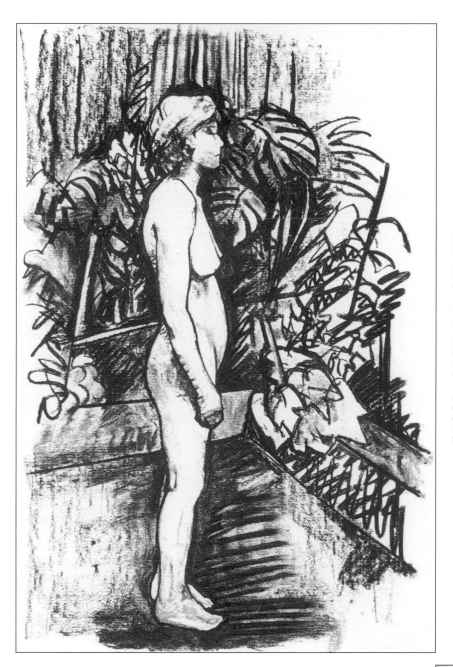

Seated Figure Using Graphite Powder

*The overall effect of a drawing executed in pure graphite powder is a subtle,
impressionistic one – as if the artist had taken a fleeting glance and quickly
described the basic tones and shapes of the subject.*

Graphite is best used for describing
tones, not for creating a highly
rendered, detailed drawing. When
applied with the fingers, the artist
can render the figure in contours
and directional strokes that both
follow and shape the form.

It is this particular aspect –
working in tones rather than line –
that gives the medium its unique
softness and subtlety. However,
pure graphite powder has a
slippery quality, and because it is
so easily applied to the surface, the
artist must avoid losing control of
the drawing. If mistakes are made,
however, they can be easily rubbed
out with a rag and turpentine.
When used with turpentine, a range
of tones can be created from very
pale greys to bold and intense
blacks. Coupled with the use of
a clean pencil line, the tones of
the graphite will lend a soft,
atmospheric mood, regardless of
subject matter.

1 Dip your fingers in a bowl of
graphite powder and black in
general shadow areas. Rubbing
harder will create darker tones.

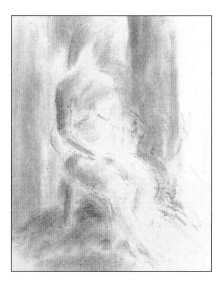

2 With a 4B pencil, rough in figure outlines and further develop shadows within the figure.

3 Dip a small rag or cotton bud in turpentine and rub onto the surface. Wipe out mistakes or false highlights with a clean rag and turpentine.

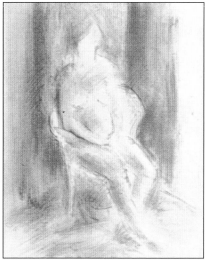

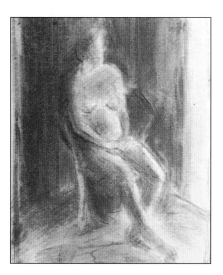

4 Dip a clean cotton bud in graphite and work around the figure, darkening the background.

5 Darken the background to bring out light areas. Reinforce figure outlines in pencil. Work around the figure with a rag dipped in turpentine.

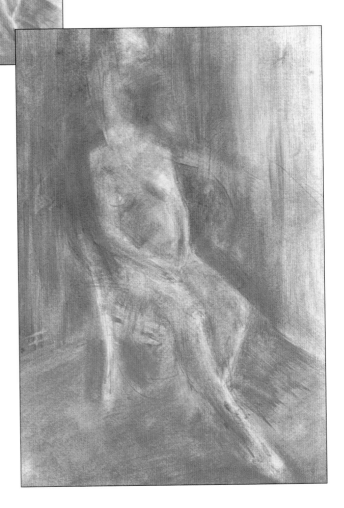

DRAWING WITH FINGERS
BLENDING WITH TURPENTINE

The fingers are first dipped into the pure graphite powder and then applied directly onto the drawing surface. The pressure and amount of powder will determine the density of tone.

With a small tissue dipped in turpentine, the graphite can be blended and worked to create a variety of tones.

Seated Nude in Pen & Ink

While pen and ink may at first prove uncomfortable and awkward to work with, the artist will soon develop a natural feel for the movement of the pen, the flow of the ink and which gestures produce which marks.

The pen-and-ink draughtsman creates a drawing from the use of the white of the paper, the black of the ink and the many tones in between these two. These tones are usually created by the use of individual lines on ink that, when laid over one another in various directions, create a meshlike effect, giving an impression of shadow and depth. Unlike other drawing and painting media, the pen-and-ink artist is limited to the use of line for developing tone, but, as demonstrated in this drawing, creating a highly modelled, accurate drawing presents no problem despite this limitation.

In this drawing the artist, with a minimum of detail, has accurately rendered the figure. The simple use of outline and shaded, cross-hatched areas alone gives the figure shape, dimension and weight. The tone created by pen and ink can be very subtly varied and need not have a harsh black-and-white effect, if carefully graduated and controlled. If you look carefully at the area of the hand resting on the knee, you will see that only loose, rough strokes have been used to describe the shadow areas.

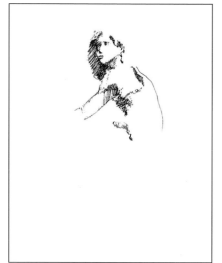

1 Sketch in the figure very roughly with a 2B pencil. Put in general outlines in ink and begin to describe shadow areas.

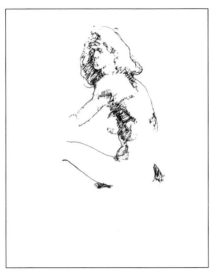

2 Continue the outline of the figure and return to put in shadow areas. Use a hatching stroke to define muscles.

3 Continue to outline the arm. Moving outside of the figure, very loosely put in broad strokes, working in one direction.

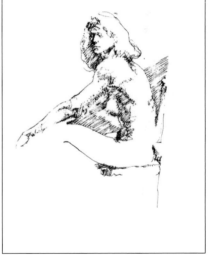

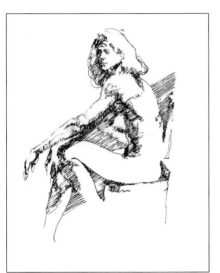

4 Continue down to the hands and legs of the figure, putting in outlines and then working into shadow areas with light strokes.

5 Carry the background tone down behind the chair using similar directional strokes. Leave the white of the paper bare to define the chair shape.

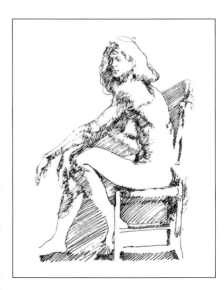

DEFINING SHADOW AREAS

Broad areas of light hatching are defined by using a dark outline to enclose the strokes.

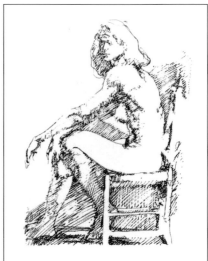

6 Changing the direction of the line, put in a general shadow over the leg. Cross-hatch over the background shadow to create a denser tone.

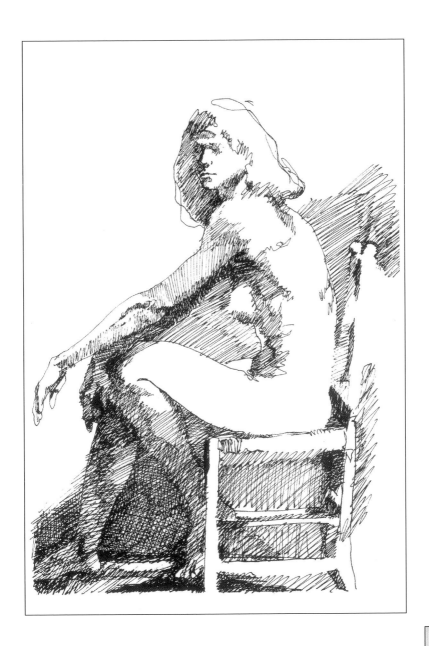

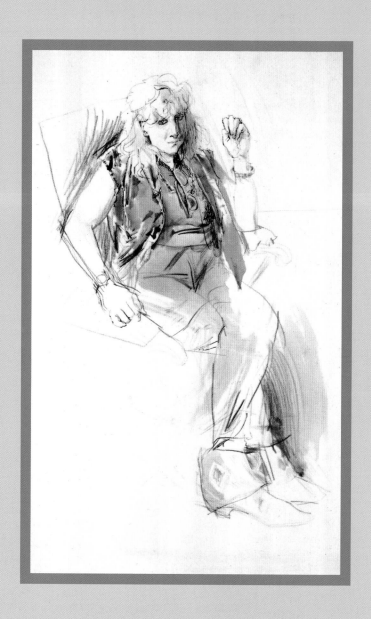

DRAWING THE CLOTHED FIGURE

Representative figure drawing depends upon the ability of the artist to see what is actually there, rather than what is thought to be there. Training the eye to discern the subject's true characteristics is of greater value than manual dexterity. When preparing to draw the figure, it is important to be aware of the qualities of the body's natural clothing, the skin and of the drapes or clothes covering the body, while at the same time understanding the anatomy.

On healthy bodies the skin usually fits snugly, naturally keeping pace with increasing or decreasing size. Although on the very old or on people who have suffered a sudden weight loss, the skin tends to sag and hang loosely about the body, it is by nature elastic and resilient. However, at the back of the knee and the elbow and in the groin, where the joints under the skin allow movement of the individual sections of the limbs so the skin is

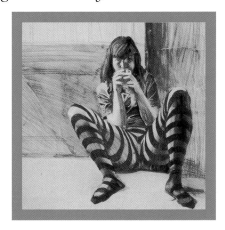

constantly being pulled and relaxed, permanent creases can be seen on most people. These creases are useful points of reference; when making figure drawings many artists begin by mapping out their relative positions.

The quality and texture of skin varies from person to person and this causes its appearance to differ. If skin is not protected from the elements by clothing, the style of which is often dictated by fashion or climate, it tends to lose its naturally soft texture. When compared with the soft, new skin of a baby, for example, a sailor's weather-beaten face seems almost leathery. Areas usually exposed to sun and wind are naturally darker and often coarser than areas that are usually covered; skin will adapt and form protective layers when necessary. The dark skin of races from countries where the sun shines powerfully and more consistently has evolved to form a permanent protection against harmful rays.

Skin texture also varies over different parts of the body. The facial skin of a lady from the nineteenth century, for example, who never allowed herself to sit in direct sunlight because beauty was partly measured by the fairness of skin, may even have been given translucent qualities by an artist who wanted to give depth to a painting. The palms of her hands could not have been treated in the same way, their skin probably being a little tougher and more textured. It is interesting that probably as a reflection of the fashion for fair skin, conventions from the past have stipulated that a lady's skin should always be painted a paler colour than a man's.

The colour of flesh is, however, subtle and infinitely variable. Each person has an individual skin colouring, which itself varies from one part of the body to another. Over the years, many different formulas have been suggested for the mixing and underpainting of skin colour to allow just the right hue to shine through subsequent glazes. Before painting, variations in colour and tone across the body must be carefully observed. Changes may occur depending on whether the bodily temperature or emotional mood of the model changes or if he or she has recently engaged in strenuous exercise.

An artist will often find that the surroundings also influence the colour of flesh. Because of the reflective quality of skin, the nude figure picks up colours from nearby objects that, in turn, greatly affect the mood of the painting. By surrounding the model with a deliberately chosen range of colours, the atmosphere can be altered and controlled. Painters sometimes compare colours that

they are mixing with white, a piece of white paper for instance. This makes it easier to judge tone and make adjustments until the colour is satisfactory.

The use of drapery or clothing on the figure is at its simplest an extension of the skin and can be treated in a similar way. Just as with the nude, there are certain bones and muscles that determine the surface form, so these continue to dominate the shape of the clothed body. Even when the figure is draped in an all-enveloping costume, the solidity of form can be retained by finding clues to the structure and concentrating on them more fully. Folds and creases often give an idea of the underlying structure. Drawing is a selective process; the trick is to know what to look for and to record those lines and masses that indicate the shape of the body while perhaps ignoring those that are merely transitory or superficial.

Just as the use of certain colours can evoke particular moods, so the choice of clothing the figure wears can bring about differing emotional responses in the viewer. Some kinds of cloth are more clingy than others. The qualities of silk and satin are, for instance, not at all the same as those of wool or linen. The former are flimsy, lightweight materials that serve to cover the flesh while revealing the form, whereas the

latter are thicker and retain much of their own character and are less affected by the shape of the body underneath. The more tactile silks and satins are a popular choice when the female body is being represented as an object of desire.

The more robust types of cloth often reduce the figure to a simple outline that, depending on the purpose of the painting, can be satisfactory. Simplifying by a process of selection is common practice in all visual representation, made easier if the form is not complicated by elaborate, creasing clothes. Using large areas of flat colour can give greater impact to other parts of the picture that are worked in more detail.

Where portraits have been commissioned, the artist will often have been required to paint the sitter in some kind of formal dress and this will necessarily have become an important element within the picture. Some of the most sumptuous and elegant portrait paintings show the subject displaying various signs of wealth and status. It is not surprising, after all, that the sitter should wish to be viewed by posterity looking at her best. In this type of work, the costume can dominate the painting, making a rich and intricate pattern of folds and pleats in a variety of textures and colours.

Because of the constant changes in the world of fashion, paintings

that portray clothes in the style of the time are important pieces of historical documentation. From this point of view, genre paintings, which show ordinary people doing everyday tasks, are even more valuable sources of information since they are not dependent upon the approval of the person paying. The artist has complete freedom to show reality even in its less attractive aspects.

It has been common practice for centuries to paint figures in contemporary clothing in order to update old stories, making them more relevant to the ordinary man or woman. Pre-Renaissance and Renaissance artists employed this device in their religious frescoes, which helped to carry the message across to the illiterate faithful, showing characters from the Bible as ordinary people such as they might meet any day. This meant that the farmers, artisans and shopkeepers of the time could identify more easily with their biblical counterparts and recognize them as mortals rather than saints. It also meant that local dignitaries could increase their self-importance by modelling for the more illustrious characters represented.

Often, however, costume portrayed little contemporary or historical accuracy and was used simply as a means of giving structure and unity to a complicated composition. Mannerist painters from late-sixteenth-century Italy, for instance, used swirls of drapery to give dramatic emphasis to the movement and gestures of their figures, filling the picture plane with activity. They included trailing swaths of cloth as an important element within the composition, rather than an accurate rendering of a garment that could actually be worn. These large and energetic paintings full of tumbling figures relied on their curving masses of drapery to hold them together and, incidentally, to fill gaps that would otherwise reveal miles of landscape. The conviction with which the artists represented cloth hanging or billowing in the breeze is often countered by an air of unreality because of the bright, even brash, colours and the overwhelming grandeur of the scenes.

To draw or paint the figure with conviction requires a sound working knowledge of its anatomy; similarly, the artist must investigate and become familiar with the anatomy of cloth to be able to make full use of the way its folds can emphasize or conceal. Artists' preliminary drawings often include careful studies of pieces of drapery. Numerous investigative sketches of this sort will encourage increasingly confident representations of a variety of textures and qualities. By noting how sharp creases give way

to soft folds and by observing the differences between the character of free-hanging material and that which is draped over a solid object, the artist acquires a repertoire of visual language that can be used to inform paintings of the clothed figure.

An interesting experiment in drawing, and one that is frequently given to students in art schools, is to set up a still life group using objects that have a clearly defined shape, such as boxes or bottles, and then to cover it with a plain piece of cloth. By softening the outlines the artist is forced to give greater consideration to tonal qualities and to treat the group of objects as a single, solid form in space. Individual details will be lost but a unity and monumentality will compensate. A very ordinary collection of objects can become mysterious and interesting when presented in this way. In the visual, as in other fields of art, the statement is often given greater potency by that which is left unstated.

Repeating this experiment but using, instead of the plain piece of cloth, a number of different coloured pieces, preferably with very positive surface patterns, will show how the entire effect can be changed, although there is no alteration in the structure of the group itself. The character of the objects underneath will be dominated by the noisy chatter on the surface. By emphasizing the decorative quality of the cloth, the volume and solidity that were so positive in the previous group become far less apparent, and sometimes unrecognizable. It is easy, at this point, to move away from objective realism into the realms of abstract painting. Paint applied as flat areas of bright colour will tend to destroy any illusion of depth. Using colour and tone skilfully, an artist can control the level of abstraction. Many painters employ a system of simplifying and flattening shapes to create pictures that, although figurative at the outset, no longer have any apparent link with reality. Some find this a fascinating area for study and have devoted a great deal of time and energy expanding on this theme.

The same experiments can be tried using people instead of objects underneath the drapes, and similar effects can be observed. A model posed in a reclining position will take on new dimensions when entirely covered by a large sheet. The interpretation of reality can become much more personal when the immediately recognizable aspects of the figure are hidden. Having learned how to represent the figure as a working machine, the artist is free to focus attention on particular areas that can be distorted or disguised at will; the

figure can be used as a starting point only before moving on to highly subjective and fantastic images. The parallel between the draped figure and a gently rolling landscape has been exploited by a number of artists, some of whom have chosen to use this as a deliberate visual metaphor. When the viewer is forced to see the human figure from a new angle, its very familiarity makes it exciting.

Below: THREE FIGURES IN AN ATTIC
In this modern painting of three figures in a garret room, the artist has created a still, cool atmosphere by establishing a single light source, which bathes the models.

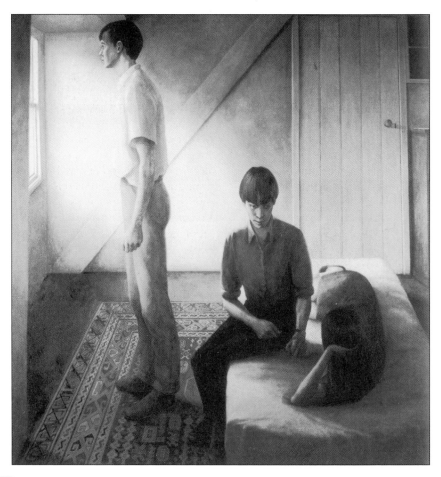

Girl in Feathered Jacket

The richness and subtlety of the pastel medium enables the artist to work with freedom, making a variety of marks while at the same time maintaining and reinforcing the initial drawing.

It is possible to establish a wide range of shades and tones using different techniques, including hatching and cross-hatching and overlaying and blending colours. Otherwise, if a multitoned effect is not desired, a large number of different colours and shades are readily available from art suppliers. The real beauty of the pastel medium is its purity. It is one of the most direct ways of applying pigment to a surface, being only lightly bound in gum. The resulting brilliance of each colour and the way pastels allow artists to work directly in blocks of colour or with a linear approach are the most obvious reasons for the popularity of the medium. Its disadvantage is that pastel tends to crumble easily and needs delicate treatment and frequent fixing at all stages.

Ascertaining a subject's tonal values is important in any medium, particularly with pastels because it is worth taking advantage of the wide range of colours and tones available. Viewing a subject with half-closed eyes cuts out a certain amount of detail and allows tones in the subject to be matched and contrasted. The main problem in this drawing involved relating the predominating areas of mid-tones – the skin, jacket and background all being of a similar intensity.

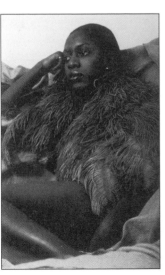

1 The model is in a relaxed and comfortable pose, semireclined on cushions, her head resting easily on a crooked arm and her legs pulled up towards her. The artist chooses to view the subject by placing himself to one side so that the model's left shoulder gains prominence. The structure of the composition is nicely balanced, with the crooked arm and the bent leg almost creating a vertical symmetry.

2 The focal point of the composition is the slightly angled head and the artist establishes this area by drawing quickly in soft, brown pastel. Outlines are drawn first, but the artist fills in the face with considerable detail to get a feeling for this crucial area of the composition.

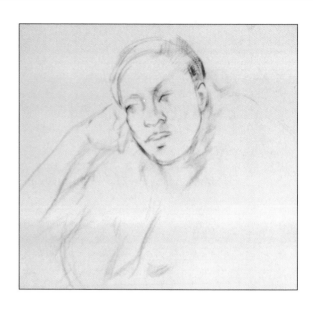

3 This linear approach allows the relationships between the model's face, fingers and the open neck of the feathered jacket to be built up spontaneously. The artist chooses to represent the shaded areas not by filling in the appropriate shapes with flat, dark tones, but by overlaying loose, broad strokes so that each line retains an individual character. This gives the drawing a liveliness and depth and helps to establish a wider tonal range. The rough texture of the paper shows through, also giving the composition an added sparkle and vivacity.

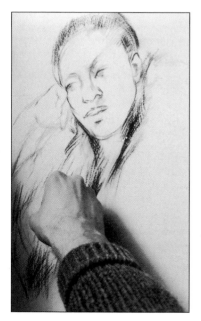

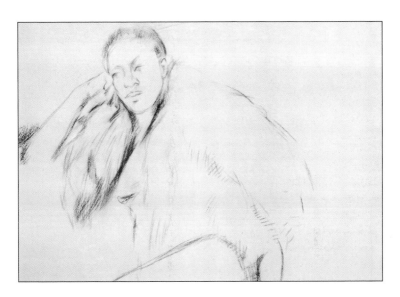

4 With the key section of the drawing firmly described, the next stage is to block in the rest of the form. The importance of the line of the crooked arm, which leads the eye to the subject's face, is reinforced by the line of the bent leg, giving an overall harmony to the composition. Even at this early point in the work, the quality of space is well defined, the positive and negative shapes having equal importance. The lines describe not only the form of the figure, but also make the undrawn areas on the paper work well.

5 The problems of successfully rendering form with light and shade are acute, whatever the colour of the skin. Here the artist is concerned with developing tonal qualities and bringing out the contrast between the smooth flesh of the model and the interesting texture of the feathered jacket. The dark areas of the hair and neckline are reinforced. The

subject is sitting in natural light, which is coming from the left-hand side.

177

6 The flexibility of pastel means that the artist can alternately delineate and shade. Here, loose strokes of light mauve suggest the softness and bulk of the jacket, while areas of hatching bring out the shadows.

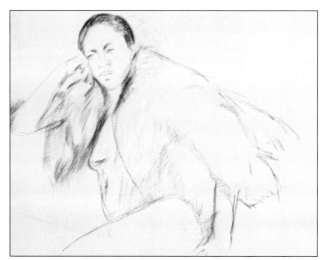

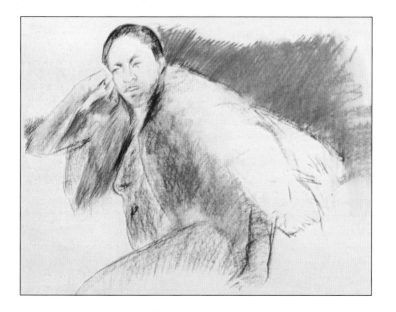

7 A vivid, blue-green background is added, the shade being echoed on one side of the jacket.

Other colours are introduced and the basic flesh tone laid.

8 Towards the final stage of the drawing, light hatching is overlaid on areas of blocked-in colour to make accents and highlights.

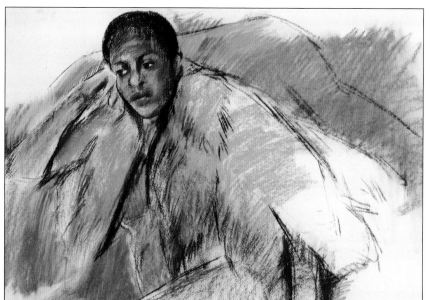

9 One of the particular problems facing the artist here is the similarity in tone of flesh, jacket and background. In the finished drawing, all areas are firmly established, while the spontaneity of the original sketch is retained.

Seated Lady in Pencil

The general impression of this drawing is similar to an old photograph or print due largely to the colour of the paper and the soft pencil tones. The picture shows how pencil can be used with a light, subtle touch to create a peaceful, stable atmosphere.

The effect is also similar to the drawings of the French artist Georges Seurat, who was able to create tonal areas duplicating the pointillist technique by using rough paper and a soft, dark crayon. A rough surface will lessen the linear effect of the pencil and blend tones more evenly than smooth paper.

The artist here depended upon the use of tone to create an illusion of space and depth, and as seen in the head, this can heighten the overall emphasis of the figure within the picture plane. Although most of the page is blank with no indication of the environment, putting the dark shadow area outside the face gives an impression of depth and space.

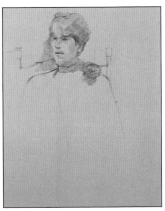

1 Lightly sketch in the outlines of the figure with a 2B pencil.

2 Begin to very lightly put in the shadow areas with loose, directional strokes. Add dark details around the neck.

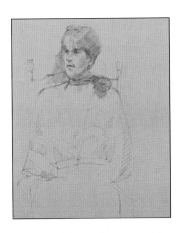

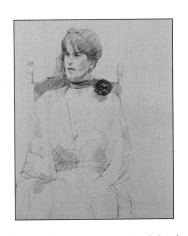

3 Work back into the hair with more pressure, building up darks. Strengthen the face and chair outlines.

4 Begin to work outside of the face with very light strokes. Carry this over to the flower shape.

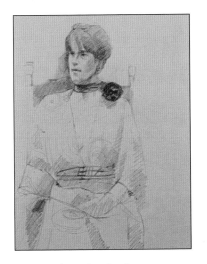

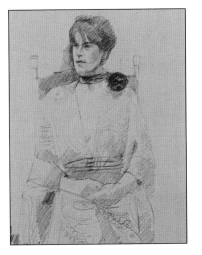

5 Strengthen the shadow areas within the figure. With a 2B pencil, work down the figure, roughing in general outlines and shadow areas.

6 With a 4B pencil, strengthen the details of the face and flower. With the same pencil, darken the shadow areas in the dress.

CREATING TONES WITH A PUTTY ERASER

The artist works into the facial details using a combination of grey tones and the clean paper surface to describe shadow and highlight areas.

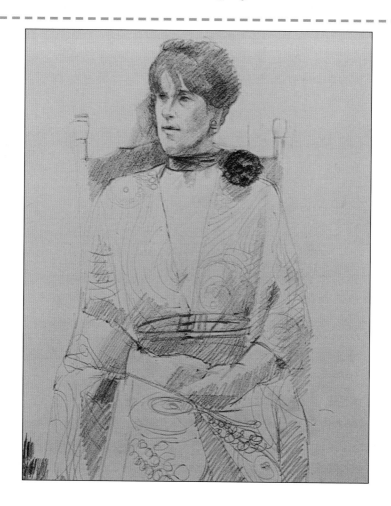

Seated Figure in Pen & Ink

A rapidograph was used for this drawing rather than the traditional pen, nib and ink, as it gives a more consistent line. Thus the artist could develop fine areas of cross-hatching without fear of dripping. By leaving the white paper untouched for highlight areas and using hatching and crosshatching to describe shadow areas, the artist has created an interesting drawing.

The rapidograph is a sensitive and temperamental tool. The artist must have a light touch and hold the pen nearly upright to keep the ink flowing. The pen should be shaken frequently in this position to make sure the nib does not clog. The paper used with a rapidograph should have a very smooth surface, otherwise the fine hairs of the paper will rip and clog the nib.

Until familiar with the rapidograph, it is worthwhile to experiment with the various textural effects available. Note that in this drawing the artist has used small areas of cross-hatching to build up the shadow area, changing the direction of the line to avoid building it up too densely. A huge variety of textures can be created by simply varying the direction and thickness of the line.

1 Carry the outline down the figure with the same consistent pressure.

2 Begin to develop the shadow area in the elbow by lightly hatching and cross-hatching in small areas, working the line in different directions.

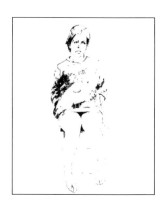

3 Work over the figure and hair, developing shadow areas. Watch the balance of light and dark carefully and move back to judge tones.

4 Put in dark areas of the chair seat with dense cross-hatching.

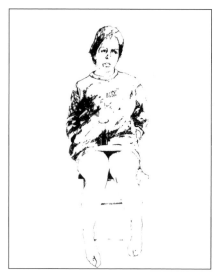

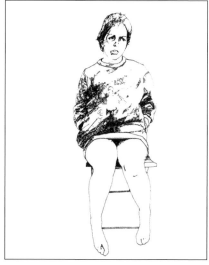

5 Work into the face, and with a very light stroke, put in the shadow areas.

6 Continue to work on the shirt and head, heightening dark areas by overlaying strokes in different directions.

CROSS-HATCHING TO CREATE TONE

Whether a rapidograph or traditional dip type, the pen relies on the use of line to create tone and texture. Here the use of fine lines of hatching and cross-hatching are being used to create subtle tones and shadow areas.

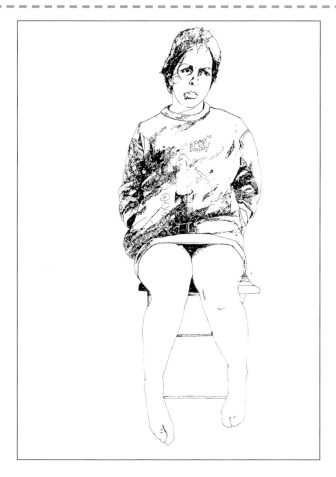

• DRAWING THE CLOTHED FIGURE •

Drawing Children

*Making posed drawings of children presents an instant practical problem –
keeping them still for long enough to complete the drawing! A sleeping pose
is an obvious answer, although in the case of a baby, this can come
up against the problem of pillows and bed linen.*

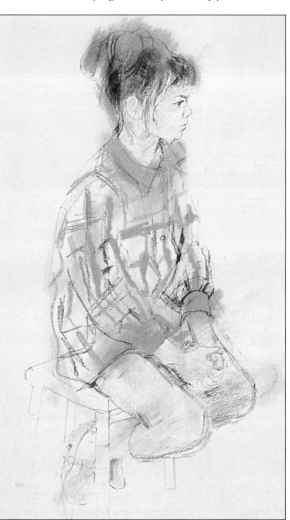

Older children are often initially keen to cooperate with an artist, but sometimes they promise what they cannot deliver, starting with good intentions that fade away through fidgeting and movement.

The real answer is speed and practise. Through the latter,

GIRL WITH YELLOW CHECK DRESS
This drawing uses water and acrylic paint to introduce colour areas. The careful, nervous linear quality in the head colours and other parts is achieved with a 'stop and start' line, the artist looking hard at the subject and back to the support. The resulting pauses are seen in the ragged feeling of the line itself.

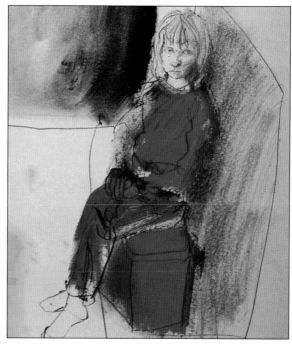

GIRL ON FIRE BOX
Using a pencil on a sheet of watercolour not surface, the overall design was indicated. A rag dipped in turpentine was used to apply colour (above) with two tubes of oil paint, cadmium red and cerulean blue. Careful smears of both colours were used to suggest the pants, sweater and box. Next, using an HB pencil as well as a 4B, details were sketched in to relate the parts to each other. The turpentine was used again to dissolve the heavier black pencil marks in some areas to increase the sense of distance and to create atmosphere.

the pace of drawing is increased so that a number of brief sketches can be assembled, from which one can create a more finished piece of work. Lighting should not be harsh; it should be gentle, yet firm. Remember that the forms within young heads and bodies are small and subtle, but the forms themselves are often large and full. Taking the head of a child as an example, the head is a simple bulking form, the cranium being larger in proportion to the face than it would be in later life. Look carefully, too, at colour, if you use it, since this will need to reflect the fresh, light quality of flesh tones and shadows as well.

The actual techniques that can be employed vary greatly, though there are some obvious limitations. The heavy charcoal lines of a Käthe Kollwitz–style drawing, for instance, are likely to be less reflective of infant character than

some others. This, however, does not mean that a thin, tentative tracing is the alternative; toughness and sensitivity go hand-in-hand when used by a sensitive draughtsman. When drawing a child, select a pose that stresses the prime characteristics.

SEATED CHILD

In coloured pencil drawings, the work's size is determined by the thin marks the pencils make. As flat areas to enhance a monochrome sketch or when used for a complete work, the colours give a rich quality to the surface. Usually, the support is white; this allows one to make use of the transparent nature of the rubbed pencil lead.

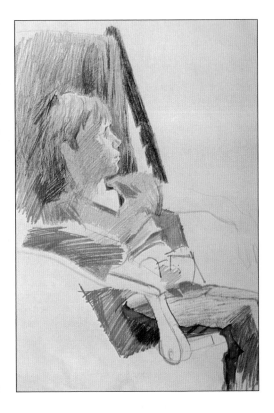

This drawing of a seated boy is on a sketchbook page (coloured pencils are ideal for use with a pocket-sized book). The main parts of the drawing were outlined in several different, light-toned pencils. Elaboration was slowly built up using single colours and juxtaposing two or more to achieve an optical colour mix. Some areas were left in their original state to contrast with those considered to be more important, such as the head. As the mixture of colour and tone (left)

slowly described the forms of head and face, the values of cool to warm became increasingly important. Beneath the chin,

for instance, the introduction of cool areas of reflected light can be seen. Alongside the warmer colours used for the facial features, this allows for the strong turn of plane needed here. In the hair, an apparently strong colour area is in fact composed of differing tones and colours. Here, too, cool areas work alongside warmer ones, blues contrasting with browns.

BOY IN DUNGAREES

The figure of the child is dominated by the large window, so he appears isolated and vulnerable. This theme has been extended by combining detailed pencil drawing with a broad expanse of wash filling in the shape of the curtain. This almost destroys the balance of the image and is intended to emphasize a sense of threat. The wash is made with watercolour in Payne's grey, which has a heavy tone reminiscent of a stormy sky. The greys in the pencil drawing are quite different in quality and texture and it is an unusually bold idea to divide two sections of a drawing so emphatically by the techniques used. The child is drawn in detail,

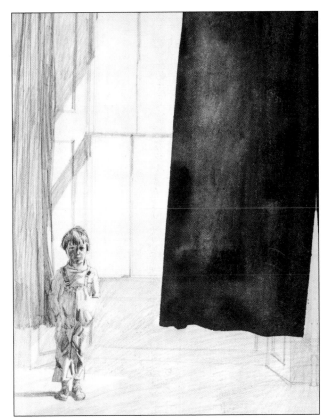

with his features clearly defined and all the creases in his clothes represented. The freely drawn shapes in clothing and curtains contrast with the crisp lines of the window that were put in using a ruler as a guide.

A well-sharpened 3B pencil is suitable for a fairly intricate drawing, as it can be used to make sharp linear marks or to lay in areas of soft tone. The artist has made use of the full range of qualities (left) in drawing the figure. The wash of watercolour is laid into a brief pencil outline with a soft sable brush (far left). The tone is varied to suggest gentle undulation in the fall of the curtain.

189

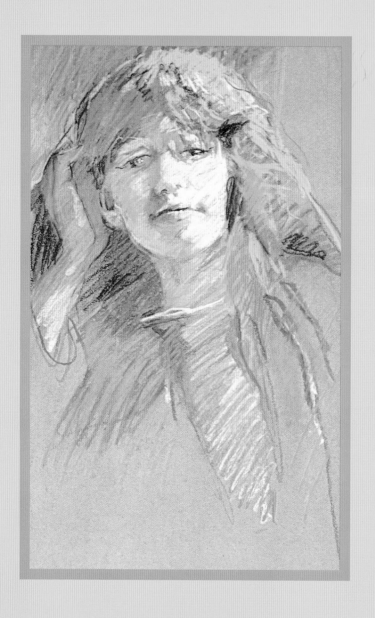

PORTRAITS

Over the centuries, each period of art has produced its own groups of portraitists, with practically all the great masters working in the genre. Their aim – as yours should be – was not to produce photographic-type reproductions of their sitters; though achieving a reasonable likeness is important, a true portraitist should aim to produce something more. The ideal is an almost magical blend of elements that give some insight into the character of the sitter as a whole.

The key to this is a combination of finely focused observation with a logical and technical approach. Many artists, for instance, use the 'gridding' method of drawing. They project the face and head forwards onto an invisible, yet understood, grid on the support. The system enables horizontal and vertical reference points to be established more easily. Look across the face of your sitter and plot the key horizontal points, working down vertically from each one in order. It is best to start with the eyes, as this enables you to pick up the corners of the mouth, nostrils, jawline and so on. The process will ensure the accurate location of all features. It is also advisable to examine your sitter from all angles, so you understand the complexities of facial structure better when work starts from one position.

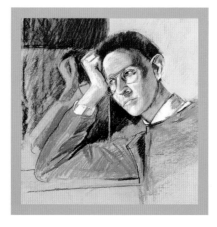

Portrait Analysis

The physical structure of the face is complex, but with intelligent observation accurate and sensitive drawings can be achieved.

This, however, is not the only aspect to be taken into consideration, for in addition to building a head in chalk, pencil or pen and ink, there is another dimension to our understanding of the human face. Concepts such as personality and communication through eye contact cannot be ignored. The face in repose might not fully express the individual and a drawn likeness must capture tilts and twists and other infinitely subtle movements.

HEAD SHAPES

Before examining features, both independently and in groups, consider the mass of the head and its relation to the skull. Just as students are taught to base the figure on geometric forms – cylinders, cubes and spheres – this same principle can be invoked in describing the head. Some artists choose an egg form and represent features by cutting into and adding onto it – making a deep cut to form the eye sockets beneath the brow or rendering the nose by adding a half-cylinder. Others prefer a block form, based on an elongated cube and chiselled to express the character and shape of the features. Yet again, others will mix the two or select a

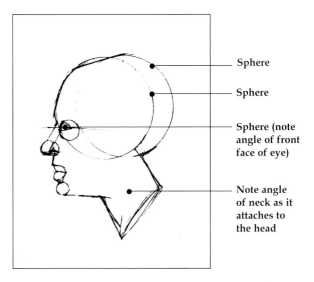

Sphere

Sphere

Sphere (note angle of front face of eye)

Note angle of neck as it attaches to the head

Side view of the head showing how the basic shapes can be expressed in terms of geometric forms. It is important to note the angles at which these shapes interrelate with each other.

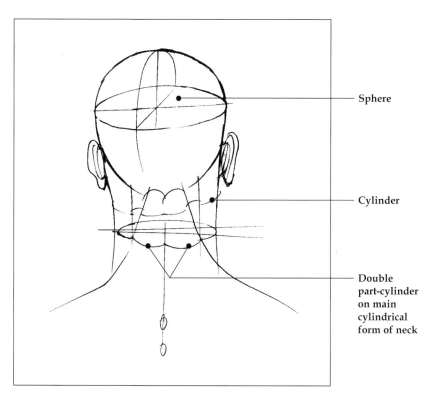

Sphere

Cylinder

Double
part-cylinder
on main
cylindrical
form of neck

• PORTRAITS •

Back view of the head showing how the basic shapes can be expressed
in terms of geometric forms.

form comprising a sphere on top
of a smaller elongated cube, thus
suggesting the cranium and lower
face and jaw. The latter form is
dependable and tolerably accurate
in anatomical terms. Onto the
chosen base the nose and other
features can be placed, and it is
important that the type of form
selected is easy to place into the
rules of perspective.

The mask within which the
features are located can best be
expressed by being enclosed inside
an inverted triangle – this is a good
general guide – and it will vary
considerably according to sex, age
and type. The overall relationships
of cranium to face differ greatly
according to age – an infant has a
much bigger brain case relative to
the mask than an adult, and the
eyes are bigger in proportion to the
other features, just as the mouth
tends to be shorter in width but
fuller in the lips. As the child moves

through adolescence and into adulthood, the proportions of the face change.

There are distinctions between the facial structures of the different sexes and an understanding of these is essential if portrait drawing is ever to be attempted. The differences are best seen in profile, where the overhanging angle of the forehead and protruding jawline of the adult male contrasts with the gentler arc of the female forehead and the smaller structure around the muzzle, where the chin is less aggressive and more delicate in its line. From the front, the mouth of the male tends to be wider, the brow deeper and the jawline harder.

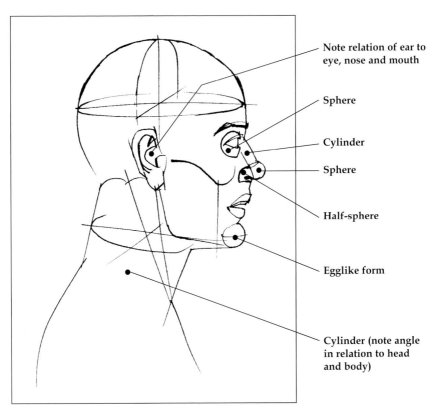

Side view of the head showing how the basic shapes can be expressed in terms of geometric forms.

Note relation of ear to eye, nose and mouth

Sphere

Cylinder

Sphere

Half-sphere

Egglike form

Cylinder (note angle in relation to head and body)

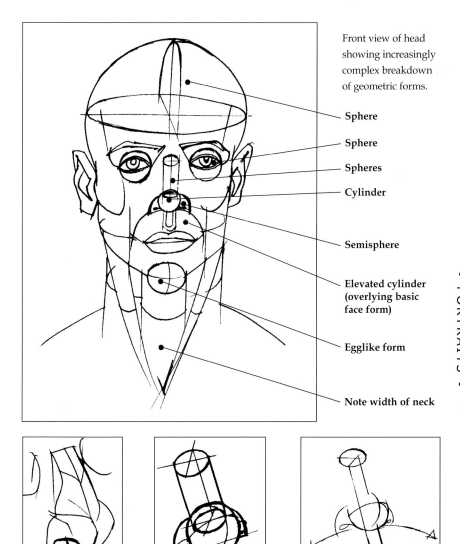

Front view of head showing increasingly complex breakdown of geometric forms.

Sphere

Sphere

Spheres

Cylinder

Semisphere

Elevated cylinder (overlying basic face form)

Egglike form

Note width of neck

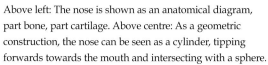

Above left: The nose is shown as an anatomical diagram, part bone, part cartilage. Above centre: As a geometric construction, the nose can be seen as a cylinder, tipping forwards towards the mouth and intersecting with a sphere.

Right: The almost infinite range of movements of the mouth requires a unique musculature.

Structure of Faces

To draw faces in proportion, you need to pay particular attention to the dimensions of the features and the spaces between them. Faces follow the curvature of the rounded bones beneath the skin, so for accurate proportions, don't plot the features out like a flat map, but concentrate on their solidity.

When starting to draw heads, use a medium that can be easily amended and make a broad outline that looks plausibly human before concentrating on the features. Once you can identify the structure and proportions that are determined by the skull, you will have the 'bones' of a good portrait, in every sense.

TINY FEATURES
The characteristic round, domed forehead and small features of infants and babies call for care in recording their proportions.

YOUNG ADULTS
Although faces are broadly symmetrical, even the most balanced features are rarely totally regular. Note any slight irregularities and set them down without exaggerating them.

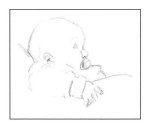

STRUCTURE OF THE FACE

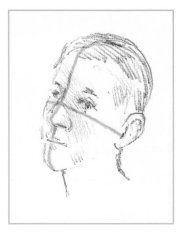

A knowledge of the underlying bones and muscles helps you to be aware of what supports and moves the skin, hair and flesh you see on the surface. Ally this to meticulous observation and look closely to distinguish between the basic structure and the fleshy superstructure that also carries the moods and emotions that make up the individuality of the sitter.

PROPORTIONS IN PERSPECTIVE

Observing faces from different angles changes their proportions. Foreshortening can hide a strong jaw or prominent forehead and can accent a previously unnoticed feature, such as an ear.

Rear views show the tiny vestiges of foreshortened features.

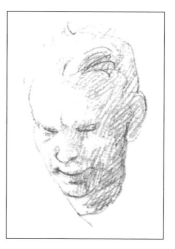

Draw unusual proportions, such as a broad brow or neat nose, as seen.

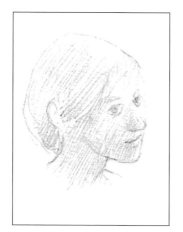

Small-featured faces retain the proportions of youth throughout life.

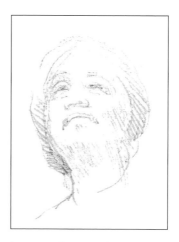

Foreshortening changes only the length of features, not their width.

The Eyes

Because it is natural to make eye contact, there is a tendency to give too much attention to eyes in the early stages of a drawing. This is usually a mistake, as it can make it difficult to structure the portrait later on.

Your first task is to show the three-dimensional nature of the eye structure. For an easy start, choose someone sleeping or find a friend who will pose with eyes closed. This avoids the distraction of the model's gaze and allows you to study the overall shape of the eyeball and the surroundings of the eyes and bony protrusions.

Try a profile to see the curvature of the eyeball and how it fits into the socket. Look for cast-shadow information, which helps reveal the form, and compare differences in widths of upper and lower eyelids. Like brows, these vary according to age, race, gender and mood. The iris will be partly occluded by the upper lid – and probably a little of the lower one, too.

JOINT FOCUS

Rely on careful observation to determine the positions of irises and how they are varied by perspective, and when you see both eyes, draw them as a pair. If you tackle each one individually, you may have problems in making them appear to track together, so assess them together and relate back frequently to the whole head. The position of any reflected light in the eyes is governed by the light source, so you need to place this carefully to maintain the illusion of joint focus. Keep tonal values appropriate, too. Highlights are often tiny, while shadow darkens even eye whites. If one side of the face is more brightly lit than the other, there will be distinct tonal variations.

MAKING SKETCHES

Although we may expect a sitter to look straight at the artist, many interesting character sketches can be made from three-quarter or even rear views. A sitter returning the viewer's gaze indicates positive interaction, while averted eyes give the subject a more passive role, possibly because she was not aware of being drawn. Concentrate on achieving a good likeness before you become entangled in details or adjustments.

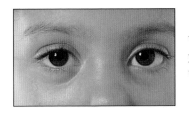

When sketching the eyes of children or young people, look to portray their smooth, unlined appearance.

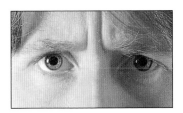

Fleeting expressions etch temporary lines on a young face, but over time they may make deep creases in an older one.

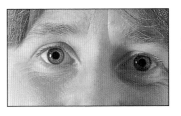

Creases, folds, and pouches around the eyes lend the stamp of character to a sketch, but be sure not to exaggerate them.

FRONT VIEW

Eyes reflect light sources, and if you light a sitter from two directions, you can expect to see highlights on both sides of the eye. Ensure you don't overemphasize them.

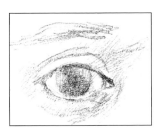

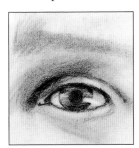

FROM DIFFERENT ANGLES

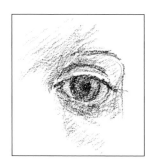

The eyeball fits into the socket under the brow bone.

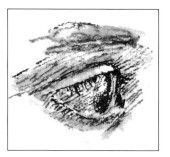

The shadowing effect of the top lid and light on the lower eyelid show up best in profile.

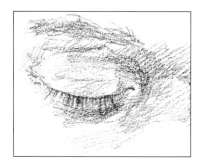

The best view of eyelashes is in relief against the skin, with eye closed.

GLASSES

Glasses can be a helpful aid in making a fine drawing. They make it easier to assess the angle of the brows and head and provide a visual link between eyes, nose and ears. To start, give yourself room to manoeuvre by choosing a medium you know is easy to erase, and make some quick, light sketches, assessing and adjusting as you go. Once you pull the drawing together around the glasses, your work will acquire a cohesion you could not achieve by drawing each item alone. Ensure you assess the tones carefully, as shadow and reflected light give substance to the lenses and reveals the space between these and the head.

Spectacles can also help you express the sitter's personality. Sunglasses block eye contact and give a slight air of mystery, while strong reading glasses magnify the eyes and give them extra impact.

The Ears

Artists who gloss over ears, seeing them as an unimportant – or too difficult – aspect of portraiture, are missing an opportunity to convey character, as these are singularly distinctive features.

Ears are not easy to draw, but the key to success is to focus on the three-dimensional aspects initially, rather than beginning with a linear rendition that can create a flat effect. Choose a broad medium, such as chalk or charcoal, that allows you to make easy adjustments, and concentrate on exploiting cast shadows or highlights that will give the ears an illusion of depth. This applies equally whether you are showing the inner whorls of the ear or depicting its emergence from the skull. Try to see the overall structure, with the ear radiating from the ear opening into which it funnels sound, with the larger part above and the lobe below this orifice.

SCALE AND DEPTH

As usual, rely on direct information to deduce the scale and depth of the ear and its angle to the head. Note the effect of hair, which may shadow or partly obscure an ear, or give it extra prominence if tucked behind.

Earrings, like glasses and clothing, are an indication of your sitter's tastes and offer an additional stamp of character to the portrait. They will also help to show any variations in the level of the ears, which are often set differently.

PLACING THE EARS

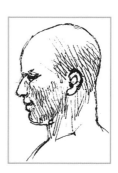

The bottom of the eye sockets is the midpoint on the face. The ears line up with the brow and the end of the nose. The front of the ear should flow into the side of the face without a break.

So much variety calls for plenty of practise, so make studies of ears, using friends and family as models.

Always start with a general statement; don't delve into detail until you have a sound framework.

MAKING SKETCHES

Left: Even when a head is almost completely turned away from view, the features are recognizable from the tiny amount visible.

Right: Seen from the rear, the ear is an important feature, so draw it accurately, paying attention to perspective.

Left: You can use the shape and growth of short hair to show form and direction on the nape of the sitter's neck.

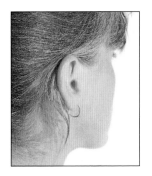

Left: With long hair, you can create decorative effects with curls, tendrils and locks, but you have to imply the unseen neck.

SIDE VIEW

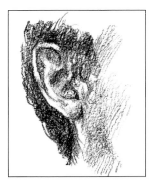

Delicate, narrow ears with small lobes are best viewed in profile.

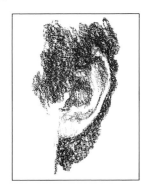

Watch for ears without lobes or where the lobe is joined to the jaw.

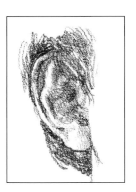

Note the scale of full, fleshy lobes in relation to the rest of the ear.

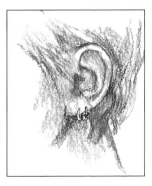

Draw earrings in perspective or they can look flat.

The Nose

To give form to a nose, you will need to think in terms of tone, not line. It is vital to show the way it stands out from the face, and if you restrict yourself to purely linear marks, you are likely to achieve a flat, two-dimensional effect.

Lines serve to mark the boundaries of tonal changes, and while they may be perfectly adequate to depict a profiled nose against a contrasting background or even a three-quarter-view nose where the bridge and nostrils contrast with darker or paler cheeks, they won't help you to tackle the graduated lights and darks of a nose in a full-face view. Choose a medium that enables you to build up tones, such as wash or charcoal, and settle down to study the basic form and the way the tonal variations express them.

The top of the nose is part of the skull, but the rest is a cartilaginous structure that is independent of the skull, like the ears, so there are equally great variations in size, shape and characteristics, again influenced by gender, race and age.

MAKING SKETCHES
Before embarking on a portrait, build up confidence and fluency with a special study of your own nose, starting by angling the light over your head for a full-face view. Take a good look in the mirror, and you will notice that although the surfaces on your face are not truly flat or level, there are definite planes that catch the light. The front planes of the nose may be highlighted, and if your lamp is a little in front of you, light will also catch the bridge and perhaps the upper curves of your nostrils. Cast shadows in the creases behind the nostrils and under the tip of your nose help to define the forms and planes.

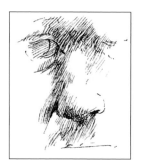

Using ink, work carefully and lightly at first.

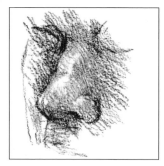

It is easy to see the nose's form with the frontal plane illuminated.

The Mouth

When you begin to make studies of the mouth, you will discover that you have a means of conveying a good deal about your sitter's mood and character.

Mouths are the most expressive of all the facial features and the most mobile, with the shape changing when stretched in a smile or half-open in speech. What the mouth is doing affects the whole face. Smiling, for example, causes a sideways extension of the circular muscle, the orbicularis oris, which opens and closes the mouth. This pushes up the cheeks, changes the apparent shape of the eyes and even slightly moves the nose.

As with the other facial features, gender, race and age are responsible for diversity and change. Female mouths are usually softer and fuller than those of males, particularly in youth; age often narrows lips and brings character in the form of smile and whistle lines. But before you begin with individual differences, you need to understand the structure of the mouth. It does not stretch in flat lines across the face; the lips follow the shape of the jaw and teeth. Trying to assess the three-dimensional form without too much initial linear emphasis will flatten the effect.

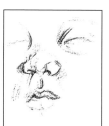

Below: Compared to that of an adult, a baby's mouth is short, with full curves and sharp tapers at the corners.

Left: Talking reveals the teeth; use fast media to capture these animated or transient expressions.

Below: In profile, open mouths may appear foreshortened.

Right: Look for distinctive mouth expressions, such as a lopsided grin.

Woman in Chinese Gown

This portrait is almost a monochrome study in black and white, except for the Naples yellow of the skin and background, yet its most immediate impact on the viewer is made by the colourful pattern of the Chinese gown.

This has been established by working in comparatively small blocks of local colour. The starkness of the basic colour scheme gives the picture a stylized look, almost like a printed illustration that has been reproduced in a restricted number of colours. It is not unlike a fashion illustration. This feeling is strengthened by the background, which consists of a stylish vase of flowers that the artist has included in a very basic, almost symbolic form.

The skin tones here have been unusually observed, and local colour is important. The shadows are predominantly in grey and black with the highlights in pure white.

The drawing was done quickly. Time was limited and the artist had to make rapid decisions about what information to record and what to discard. Colour is used simply and graphically in bold, pure areas.

It is the black shape of the hair and gown that holds this composition together. These are established with confidence, the pencil strokes alone indicating the direction of the form. The hair, for instance, is built up by overlapping a mass of dark strokes and allowing the white paper to show through in areas affected by the light. Facial tones are described in more detail but still in the same emphatic directional strokes.

The artist began by making a basic drawing using a dark brown coloured pencil. This linear drawing was developed as the blocking-in progressed, and each area was quite firmly indicated in the early stages. Although the drawing is minimal, the line has a tautness and discipline that is the result of careful observation and accurate work.

1 The model, leaning against the arm of a sofa, looks directly at the artist as she sketches her portrait.

2 Using a dark brown pencil, the artist starts by sketching in the composition and the position of the figure. Here, she draws in the head.

3 The face and features are established in light strokes of brown. Hair tones are blocked in with black.

4 Hair is built up with overlapping masses of dark strokes, allowing white paper to show through in areas affected by light. The artist works quickly and accurately, attempting to draw each line as a final statement, instead of anticipating subsequent change.

5 The smooth drawing paper allows the pencil to glide smoothly over the surface below. Lack of texture on the paper surface is compensated for by the strong directional pencil strokes that the artist uses to block in areas of colour and tone.

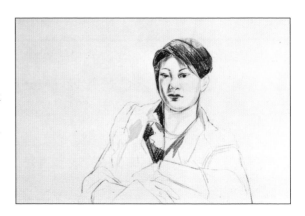

6 Fine hatching brings out the modelling on the face. Apart from the local flesh tint, there is no actual colour in the face. Shading is restricted to grey and black; highlights are represented by white paper.

7 The patterned robe is heavily blocked in with bold colours. In order to cover this comparatively large area, the artist works quickly with broad directional pencil strokes.

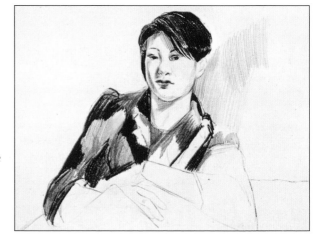

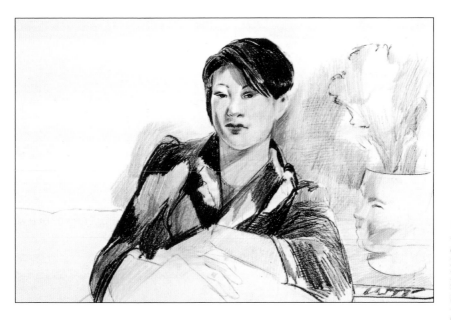

WHAT THE ARTIST USED

This rapid coloured pencil portrait was sketched on a sheet of white drawing paper measuring 37 x 50.8 cm (15 x 20 in). The artist used a selection of colours, including black, dark grey, yellow, red, dark blue, light blue, brown, violet and bright green. Coloured pencils form a compromise between a lead line drawing and a coloured painting.

Their colour range is more restricted than oils, acrylics or gouache, but new sets with an increasingly wide choice of colours are appearing continually and are gaining in popularity. Although the colours cannot be premixed, as with paints, they can be mixed 'optically' on the paper by overlaying different colours to obtain a wide range of colours.

Portrait in Pen & Ink

A portrait can be as successful in capturing a person's likeness as the traditional full-faced portrait because it clearly shows the contours of the individual's features.

In this drawing, the structure of the form is broken into a pattern of shapes by extremes of light and shadow. A strong image is constructed by using the basic techniques of hatching and stippling. The drawing uses high tonal contrasts, but note that there are no solid black areas; the darkest tones consist of layers of dense cross-hatching built up in patterns or parallel lines.

Details of texture and shadow in the face are stippled with the point of the nib. The vigorous activity in the drawing is offset by broad patches of plain white paper indicating the fall of light over the form.

Observe the subject carefully as you work, moving the pen swiftly over the paper. Pen strokes should be loose and lively or the result can all too easily look stiff and studied.

1 Hatch in a dark tone down one side of the head to throw the profile into relief. Continue to build up detail in the face.

2 Work on shadows inside the shape of the head with fine parallel lines slanted across the paper. Work outwards into the background in the same way.

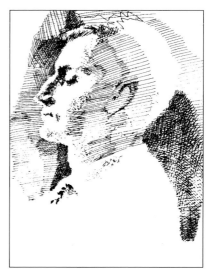

3 Broaden out the shadows and cross-hatch areas of the background behind the head to darken the tones.

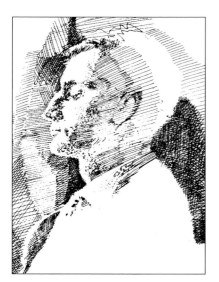

4 Vary the tones in the background, gradually covering more of the paper. Work into the head and clothes with small, detailed patterns.

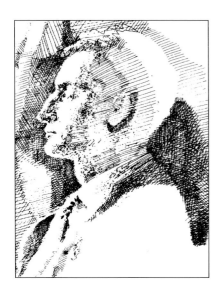

5 Draw in patches of dark tone to show folds in the clothing. Define the hairline and shape of the ear with cross-hatching.

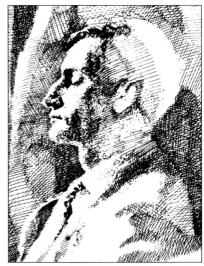

6 Work over the whole image, intensifying the tones with hatching and stippling. Develop a high contrast of light and dark down the face and body.

The initial pencil sketch of the head is used only as a reference for developing shadow and highlight areas. Note in particular how the shadows within the face and in the background create the profile of the head.

• ANATOMY & FIGURE DRAWING HANDBOOK •

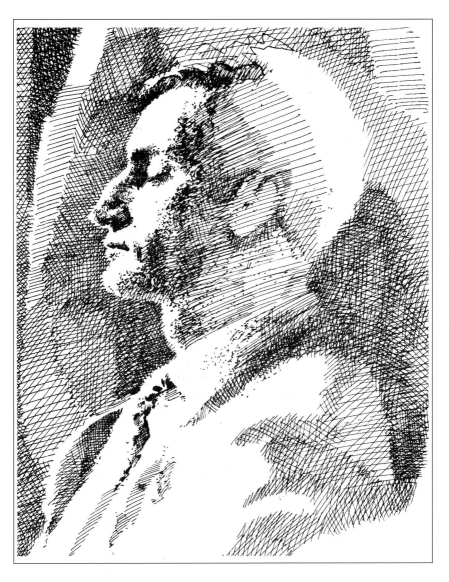

John in Pastel

The use of colour in this portrait is personal and idiosyncratic, but the dark-toned background has enabled the artist to use a lot of white with the bright pastel colours. The result is a luminous, slightly unearthly portrait.

In this large pastel portrait the artist has used her hand and fingers to blend colours in the face, clothing and background. Care was taken not to overdo these smooth areas, since too much blending can make the image blurred and soggy, which tends to destroy the structure of the drawing. In this case enough of the coarse pastel strokes are left showing through to preserve the form and structure of the subject, as well as providing textural contrast. The drawing was sprayed lightly with fixative between stages to prevent the bright colour and pure white from smudging as the artist worked. It was then refixed on completion to protect it.

A close-up view of John's face provided the artist with enough visual inspiration to produce a large and colourful portrait.

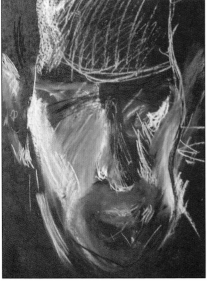

1 The artist embarks on this pastel portrait here, working on a large scale. For this drawing she chooses a dark support – pieces of cardboard treated with a coat of deep blue oil primer.

2 Using broad strokes of pastel, the artist begins by establishing the main facial tones. There is a predominance of white and pastel tones here, contrasting with the dark blue of the support.

3 Using black chalk, the artist draws in the facial features. This is drawn in linear detail and superimposed on the blended areas of light tone and colour, bringing the entire image into sharp focus. The technique illustrates the flexibility of pastels, which can be used to produce either linear effects (as the artist demonstrates in the preceding pastel portrait) or to establish extensive blocks of solid colour and tone. Although it is generally assumed that pastel is best suited to fairly broad treatment, considerable linear detail can be obtained by sharpening the pastels or by using the sharp edge of the pastel. Most pastels are too soft to be sharpened with a knife or blade, but can be rubbed carefully on a piece of sandpaper to create a point (sandpaper blocks are manufactured especially for this purpose and are available in art stores). When sharp lines and

details are important, it is a good idea to give the work an occasional light spray of fixative in between stages to prevent the image from getting smudged.

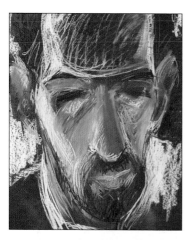

4 The pale tones are applied lightly over dark blue, and the cool underpainting shows through to create a luminous and slightly unreal image. Vivid strokes of colour are mixed with the whites, their direction suggesting the form of the face and features.

5 Strong diagonal hatching over smooth, blended areas produces solid areas of colour. Here the artist uses dense strokes of flesh-coloured pastel over a dark red base.

6 The approach throughout this painting is free and uninhibited. By holding the pastel loosely and working with a broad, sweeping movement of the arm, the artist produces lively strokes of broken colour.

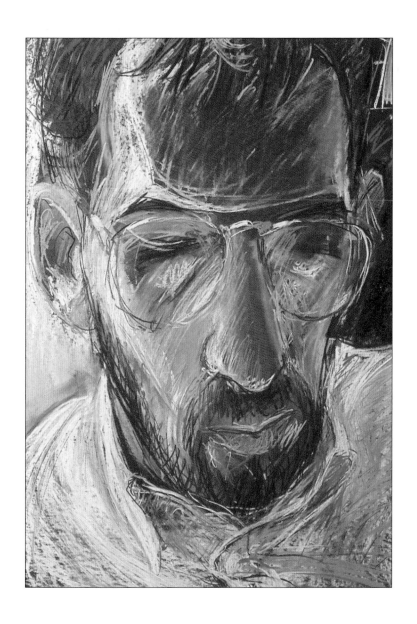

Caricatures

All portrait artists know the value of the caricature; the element is contained in all good likenesses. The art is an extremely ancient one – many artists over the centuries have created caricatures along with their other work. Examples range from Leonardo da Vinci in the sixteenth century to Picasso in the twentieth.

Traditionally, the caricature has been seen as a political art form, closely associated with social comment and criticism. Frequently, too, it is associated with humour – indeed, it is often attached to an intended smile or guffaw. The drawings usually tend to be in pen and ink or brush and ink, largely because of the demands of photo-mechanical reproduction; however, both watercolour and pencil lend themselves readily to the art form.

Your main task is to extract the essential character from your subject by selection and emphasis. Often, these changes are of a very subtle kind, despite the popular notion that most caricatures are extreme in their distortions. A successful caricature preserves a balance between reality and exaggeration, retains a strong feeling of identification with the real world, yet underlines the features that best express the individual.

Comment on a particular situation is implied in the drawing of doctor and patient; this artist takes a light-hearted approach.

Above: The overall design of this drawing works extremely well and the various individuals comprising the band are described with great gusto and humour. The rich detail of physical shapes and features is neatly combined with formal attention to pattern and tone.

Left and below: These sketches were made at an airport terminal and they vividly capture the resigned air of concentration that the subjects display as they are kept waiting. The drawings were done with ballpoint pen, originally in a sketchbook of white paper. In

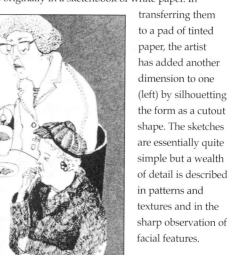

transferring them to a pad of tinted paper, the artist has added another dimension to one (left) by silhouetting the form as a cutout shape. The sketches are essentially quite simple but a wealth of detail is described in patterns and textures and in the sharp observation of facial features.

Glossary

ACROMION PROCESS The outer edge of the shoulder blade.

ARTICULAR FOSSA Socket or groove of a joint in the body; for example, the socket of a ball-and-socket joint (like the shoulder).

ARTICULAR PROCESS Any joint of the body and the elements of its constitution. The main processes are hinge joints (like the knee), ball-and-socket joints (like the hip) and rotating joints (like the elbow).

BISTRE A brown pigment prepared from charred wood used as a monochromatic wash for adding tone to drawings and also in the form of ink or chalk.

BLENDING Merging colours together in such a way that the joins are imperceptible.

CALLIGRAPHIC A term referring to a linear style of drawing. Characterized by flowing, rhythmic marks.

CALVARIA The major, rounded part of the skull that houses the brain. A more common word is cranium.

CARICATURE A representation of a person or object showing the characteristic features exaggerated, often intended as a humorous or satirical comment.

CARPAL BONES The eight bones of the wrist, forming a very unusual joint in that for articulation some slide over the top of others.

CARTOON A drawing or sketch, sometimes containing an element of caricature, showing the comic side of a situation. Also used in another context to refer to a full-size drawing made to map out the composition for a large painting, mural or tapestry.

CHARCOAL A drawing material made by reducing wood, through burning, to charred, black sticks.

COMPLEMENTARY COLOURS There are three basic pairs of complementary colours, each consisting of one primary and one secondary colour. These are opposite colours in that the primary is not used in mixing the secondary; thus blue and orange (red mixed with yellow) are complementary.

COMPOSITION The arrangement of various elements in a drawing or painting; for example, tone, contour, colour, etc.

CONTE CRAYON A drawing stick like a hard, square-sectioned pastel, available in black, white, grey, red and brown.

CROSS-HATCHING A technique of laying an area of tone by building up a mass of criss-cross strokes, rather than with a method of solid shading.

FEMUR Large bone of the thigh to which powerful muscles attach, and for protection of the hip and knee joints.

FIBULA Thinner, but not shorter, of the two bones of the lower leg (the other is the tibia); a protuberance at the lower end forms the outer ankle, protecting the talus, the main carrier of the body's weight, although the fibula itself carries no weight.

FIGURATIVE This term is used in referring to drawings and paintings in which there is a representational approach to a particular subject.

FIXATIVE A thin varnish sprayed onto drawings in pencil, charcoal, pastel or chalk. It forms a protective film on the work to prevent the surface from being blurred or smudged.

FLEXION Causing to bend (of a muscle); the opposite of extension. The muscles that cause the limbs and digits to bend are called flexors.

FORESHORTENING The effect of perspective in a single object or figure, in which a form appears considerably altered from its normal proportions as it recedes from the artist's viewpoint.

GOUACHE A water-based paint made opaque by mixing white with the pigments. Gouache can be used to lay thin washes of colour but because of its opacity, it is possible to work light colours over dark and apply the paint thickly to emphasize highlights or textural qualities.

GRAIN The texture of a support for drawing. Paper may have a fine or coarse grain depending upon the methods used in its manufacture. Heavy handmade or machine-made papers often have a pronounced grain that can modify the tones in a drawing.

GRAPHITE A form of carbon that is compressed with fine clay to form the substance commonly known as 'lead' in pencils. The proportions of clay and graphite in the mixture determine the quality of the pencil, whether it is hard or soft, and the density of the line produced.

GROUND The surface preparation of a support on which a drawing is executed. A tinted ground may be laid on white paper to tone down its brilliance, for example in pastel or chalk drawing.

HALF-TONES A range of tones that an artist can identify between extremes of light and

dark. These are often represented in drawing by techniques of hatching or stippling.

HATCHING A technique of creating areas of tone in a drawing with fine, parallel strokes following one direction.

HIGHLIGHTS The areas in a composition where the light is most intense.

HUMERUS Large bone of the upper arm; bony projections at top and bottom tubercles and epicondyles have attached muscles.

INDIAN INK A dense black drawing ink, made from carbon, that may be diluted with water but is waterproof when dry. It is also called Chinese ink.

ILIUM The major bone of the pelvis, to which the pubis and ischium eventually fuse, and on which the sacrum (the lowest significant part of the spine) sits.

LOCAL COLOUR The inherent colour of an object or surface, which is its intrinsic hue unmodified by light, atmospheric conditions, or colours surrounding it. For example, a red dress, a grey wall.

MEDIUM This term is used in two distinct contexts in art. It may refer to the actual material with which a drawing or painting is executed, for example, pastel, pencil or chalk. Also refers to the liquid in which pigment is mixed.

MODELLING The employment of tone or colour to achieve an impression of three-dimensional form by depicting areas of light and shade on an object or figure.

MONOCHROME A term describing a drawing executed in black, white and grey only or one colour mixed with black and white.

PARIETAL BONE Large, rounded bone that is part of the skull and constitutes protection for the brain over most of the upper top and back part of the head.

PASTEL A drawing medium made by binding powder pigment with a little gum and rolling the mixture into stick form. Pastels make marks of opaque, powdery colour. Colour mixtures are achieved by overlaying layers of pastel strokes or by gently blending colours with a brush or the fingers. Oil pastels have a waxy quality and less tendency to crumble but the effects are not so subtle.

PHALANX, PHALANGES The bones of the fingers (including the thumbs) and the toes.

PICTURE PLANE That area of a picture that lies directly behind the frame and separates the viewer's world from that of the picture.

PLANES The surface areas of the subject that can be seen in terms of light and shade.

PORTRAIT Of a picture: representing a likeness of a person or persons; in common usage the term generally describes a picture of a person's head and shoulders, but historically portraits have much more commonly been full-length. Of the shape of a picture: rectangular, with the longer sides vertical; such a shape is considered to impart an active, possibly even disturbing, ambience.

PRIMARY COLOURS These are red, blue and yellow. They cannot be obtained from any other colours.

RESIST This is a method of combining drawing and watercolour painting. A wash of water-based paint laid over marks drawn with wax crayon or oil pastel cannot settle in the drawing and the marks remain visible in their original colour while areas of bare paper accept the wash.

SANGUINE A red chalk used for drawing.

SECONDARY COLOURS These are the three colours formed by mixing pairs of primary colours: orange (red and yellow), green (yellow and blue) and purple (blue and red).

SEPIA A brown pigment, originally extracted from cuttlefish, used principally in ink wash drawings.

STUDY A drawing often made as preparation for a larger work, which is intended to record particular aspects of a subject.

SUBCUTANEOUS Just under the skin.

SUPINATION In anatomy, making to lie flat (supine) and open; the opposite of pronation.

SUPPORT The term applied to the material that provides the surface on which a drawing is executed, for example, board, paper or canvas.

TARSAL BONES The bones within and just below the ankle; the equivalent in the foot or the wrist.

THORAX, THORACIC The part of the body between the neck and the abdomen; the upper part of the trunk or torso.

TIBIA The shin bone, larger of the two bones of the lower leg (the other is the fibula); bony protuberance at both ends have attached muscles – the lower inside protuberance (the medial malleolus) is the inner ankle.

TRUNK The large, unified part of the body, including both thorax and abdomen but not including the limbs or the neck and skull.

ULNA The slightly larger of the two bones in the lower arm (the other is the radius).

UNDERDRAWING The initial stages of a drawing in which forms are loosely sketched or blocked in before elaboration with colour or washes of tone.

VALUE The character of colour or tone assessed on a scale from dark to light.

Index

Page numbers in italics refer to illustrations and captions.

• INDEX •

Picture Credits
&
Acknowledgements

The material in this book previously appeared in:

Anatomy, Perspective and Composition for the Artist (Stan Smith)

The Artist's Handbook Series: Drawing & Sketching (Stan Smith)

Drawing and Painting the Figure (Stan Smith & Linda Wheeler)

Figure Sketching School (Valerie Wiffen)

How to Draw and Paint the Figure (Stan Smith)

How to Draw and Paint Portraits (Stan Smith)

The Painting and Drawing Course (Quantum Books)

Painting Portraits (Jenny Rodwell)